THE ABU GHRAIB EFFECT

T0079912

The Abu Ghraib Effect

Stephen F. Eisenman

REAKTION BOOKS

For OKW

Published by Reaktion Books Ltd
33 Great Sutton Street
London EC1V 0DX, UK
www.reaktionbooks.co.uk

First published 2007
Copyright © Stephen F. Eisenman, 2007
Transferred to digital printing 2010

All rights reserved
No part of this publication may be reproduced, stored in a retrieval
system, or transmitted, in any form or by any means, electronic, mechanical,
photocopying, recording or otherwise, without the prior permission of
the publishers.

Printed and bound by
Chicago University Press

British Library Cataloguing in Publication Data
Eisenman, Stephen
The Abu Ghraib effect
1. Abu Ghraib Prison 2. Torture in art 3. Suffering in art
4. Pathos 5. Prisoners of war in art 6. Prisoners of war -
Abuse of - United States 7. Iraq War, 2003-Atrocities
I. Title
704.9'4936564

ISBN 978 1 86189 646 9

Contents

Preface 7

1 Resemblance 11
2 Freudian Slip 18
3 Documents of Barbarism 42
4 Pathos Formula 60
5 Stages of Cruelty 73
6 Muscle and Bone 92
7 Theatre of Cruelty 101
8 Orientalism 108
Afterword: What is Western Art? 111

References 123
Acknowledgements 139
Photographic Acknowledgements 141

For the purposes of this convention, the term 'torture' describes any act by which severe pain or suffering, whether physical or mental, is intentionally inflicted on a person for such purposes as obtaining from him or a third person information or a confession, punishing him for an act he or a third person has committed or is suspected of having committed, or intimidating or coercing him or a third person, or for any reason based on discrimination of any kind, when such pain or suffering is inflicted by or at the instigation of or with the consent or acquiescence of a public official or other person acting in an official capacity.

No exceptional circumstances whatsoever, whether a state of war or a threat of war, internal political instability or any other public emergency may be invoked as a justification or torture.

No state party shall expel, return or extradite a person to another state where there are substantial grounds for believing that he would be in danger of being subjected to torture.

– *United Nations Convention Against Torture*, 1984[1]

To articulate the past historically . . . means to seize hold of a memory as it flashes up at a moment of danger.

– *Walter Benjamin*, 1940[2]

Preface

The images of torture from Abu Ghraib Prison are among the most searing and disturbing to have appeared since the commencement in 2003 of the US war against Iraq. They have been reproduced in newspapers and magazines all over the world, and seen by nearly everyone with access to television and the internet. Though the few dozen published pictures are merely a fraction of the thousands that exist, their documentary significance is nevertheless clear: in this particular place, remote from the United States, and at that particular time, 2003–2004, men and women from the military treated fellow human beings with contempt and cruelty, stripping them naked, binding them, sexually abusing them, beating their bodies with fists and sticks, menacing and attacking them with dogs, killing them.[1] Such behaviour, as the UN Convention Against Torture makes clear, is illegal, can never be justified, and the perpetrators should be identified, arrested and punished to the fullest extent of military, civilian and international law. In addition, any policies, practices and procedures that permit or in any way encourage torture should be ended. This much is clear, but much else is unresolved.

Blame, for the most part, has not been apportioned, nor punishments meted out. The US Congress in 2004 received just twelve hours of sworn testimony about Abu Ghraib and issued no final reports. Four additional investigations – by the Defense Department, Army, Navy and CIA – yielded 150 allegations of torture (euphemistically labelled 'abuse'), but only a handful of prosecutions and convictions.[2] The US Army confirmed that at

least 27 prisoner deaths at Abu Ghraib were homicides, but the longest sentence received by a soldier convicted of murder was three years.[3] Though journalists, lawyers, and human right advocates have unambiguously exposed the responsibility of senior military and civilian authorities for policies that condone or legitimize torture, none have been charged with crimes, none have been dismissed, and none demoted or censured. The Abu Ghraib pictures were not debated or even much discussed by the candidates in the 2004 Presidential campaign, and the issue did not prevent George Bush's re-election. Alberto Gonzales, the author of a memo sent to the President which argued that the US possessed the right to torture detainees in the so-called 'war on terror', was promoted in 2005 from the position of White House Counsel to Attorney General. Every single Senate Republican voted for his confirmation, in addition to six Democrats.

Though President Bush suffered a significant decline in popularity in 2005–2006, that fact is largely attributable to Hurricane Katrina, high gasoline prices and a failed war effort, not fallout from revelations about the torture of prisoners in Iraq and Guantanamo Bay, secret detention facilities around the world, and 'extraordinary rendition' – the practice (specifically outlawed by the UN Convention cited earlier) of kidnapping terrorism suspects and transporting them to locations where torture is practised routinely. Given this history, it is reasonable to assume that a majority of US citizens are not much bothered by the fact of US torture. While a Gallup Poll conducted immediately after the release of the Abu Ghraib photographs indicated that 54 per cent of Americans were 'bothered a great deal' by the revelations, a year later the number had declined to just 40 per cent. In December 2005 an AP/IPSOS poll revealed that 61 per cent of Americans agreed that torture was justified on some occasions.[4] The May 2006 report by the UN High Commission for Human Rights about US torture at Guantanamo Bay was widely reported in newspapers, on radio and television, but produced no great outcries, public protests or congressional investigations. Can so many Americans have come to accept torture as a matter of dull routine?

What if there is something about the pictures themselves, and past images of torture in different media, that has blunted the natural human response of outrage? What if the sexualized scenarios, so frequently visible in the Abu Ghraib photographs, rather than rendering the images of abuse and torture more horrific, made them appear less so? What if the US public and the amateur photographers at Abu Ghraib share a kind of moral blindness – let us call it the 'Abu Ghraib effect' – that allows them to ignore, or even to justify, however partially or provisionally, the facts of degradation and brutality manifest in the pictures? And finally – and more hopefully – what if the 'Abu Ghraib effect' can in some small measure be undermined, or at least made alien by means of its exposure, analysis and public discussion?

Any effort to uncover and thereby weaken the Abu Ghraib effect will require careful attention to some disturbing photographs; there is simply no alternative. Any reckoning with their significance will require that we understand them as images located in a long history of images. Note that I use the words photographs, pictures and images to describe the evidence from Abu Ghraib. Though they possess a discernable form and structure – what the art historian calls 'style' – the pictures from Abu Ghraib, of course, are decidedly not works of art. They were never intended to be seen or exhibited as artworks (for example in galleries or museums), and their makers had no training (so far as we know) in art schools or academies or significant acquaintance with important works of art from the past or present.[5] This does not mean, however, that the Abu Ghraib pictures should be excluded from comparison with works that do belong within the history of art. Vision, seeing and representations all have histories. The visual imaginations of individuals and communities unfold over generations.

Though not all images are works of art, all artworks are images, and because of the special character of the Abu Ghraib photographs – their representation of torture and suffering in a time of war – they belong to a very large and culturally prestigious set. They contain peculiar motifs and subjects, I shall show, that have their approximate origin in the sculpture of Greco-Roman

antiquity, and reappear with regularity in much, subsequent Western art. (In an Afterword, I address the latter, problematic term.) The Abu Ghraib photographs, in short, are not works of art, but the materials and tools of art history are essential to understand them and counter their effect.

I

Resemblance

The photographs made by civilians, soldiers and mercenaries at Abu Ghraib horrified much of the world when they were first broadcast and printed in the Spring of 2004.[1] I too was appalled, but as an art historian, my anger was accompanied by a shock of recognition: even though these brutal images from a prison in occupied Iraq are not works of art – indeed, were never intended to be seen by more than a handful of people – they nevertheless insistently recalled to mind treasured sculptures and paintings from a distant past. Prisoners at Abu Ghraib were shown in the subservient position of defeated warriors from Hellenistic Greek sculptures; naked detainees from the global 'war on terror' were posed (as in a tableau vivant) like the bound slaves of Michelangelo; anguished bodies evoked martyred saints in Baroque churches. In short, modern Muslims appeared to have been transported – hooded and shackled – to the marble altar of Pergamon in Berlin, the collections of the Louvre in Paris, and the crossing of St Peter's Basilica in Rome. Was the resemblance inadvertent, or could there be a link between such temporally and culturally distant forms? Was there a common visual imaginary underlying the diverse objects and images?

But as commentary on the Abu Ghraib pictures accumulated in the successive weeks and months after their initial publication, it became clear that few of my colleagues either noticed, or having noticed, chose to comment on the striking similarities between the photographs of tortured Muslim men and women and works of Ancient, Renaissance and Baroque art made for

1 Francisco Goya, *Victim of Inquisition*, drawing from Album C (*Inquisition Album*) c. 1810–14, brush and ink drawing.

powerful kings, clerics and aristocrats.[2] Instead, most critics and art historians see in these cruel pictures the distinctive contours of modern, anti-war art – the works of Francisco Goya, Pablo Picasso, Ben Shahn and Leon Golub among others. To be sure, the visual similarities between individual images are striking: for example between a drawing by Goya from his *Inquisition Album* and the iconic image of an inmate forced to stand for hours on a box with wires dangling from his arms (illus. 1 and 2).[3]

Each is draped in a crudely cut scapular that ridicules rather than conforms to the contours of the body. The first garment is a paper *samarra* or *sanbenito* girdled at the waist and inscribed with the name of the condemned heretic and a list of

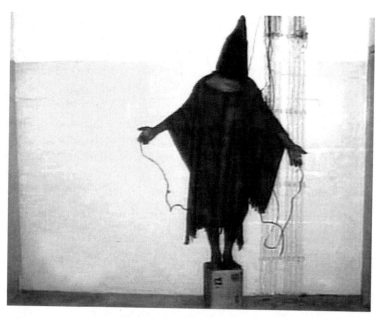

2 The prisoner known as 'Gilligan' at Abu Ghraib, 2003.

her supposed crimes; the second is a poncho, loosely draped over limbs and torso, probably fashioned by the prisoner himself from a coarse blanket, the only covering provided for him by guards and interrogators.[4] Each of the prisoners has their feet pressed together, the one by ropes, the other by the narrow confines of the small, cardboard, C-Ration box. Each wears a tall, conical hat – the first is a *carochas*, again worn by victims of the Spanish *auto-da-fé* and typically decorated with flames and devils; the second is a hood, probably made of jute, used by the US military to disorient, objectify and torture an inmate; it recalls dunces' caps once used to punish schoolchildren, the hoods worn by members of the Ku Klux Klan and subsequent American racist organizations, and the hoods worn both by executioners and their victims.

But even brief reflection on the two images reveals that any similarity between them is only superficial since – beyond the differences in costume and historical circumstance – the very purpose of the former was to foreclose the possibility of a future world like that exposed in the latter. And the gap between the

works by Picasso, Shahn and Golub, and the Abu Ghraib photographs is equally great. The modern tradition in art – from the late eighteenth to the late twentieth century – has had multiple and diverse national iterations, and encompassed many styles and subjects, but whether made in Spain, the United States, France or Mexico, it has almost always articulated a vision of subjectivity that precludes the treatment of humans as things.[5] It exists under the modern rubric of the 'categorical imperative', the idea, found in the philosophies of Kant, that individuals must act only according to those principles or maxims that they would wish to become a universal law. Whatever its particular politics, modern art – whether a landscape by Cézanne, a mural by Rivera, a still-life by Picasso, or a drip painting by Jackson Pollock – has implicitly represented the value of personal independence and autonomous thought.[6] It has first of all obeyed the injunctions of art and the rules of imagination, not the dictates of party or faction. When modern works of art have done otherwise, they have flirted with authoritarianism. The torture photographs from Abu Ghraib precisely enshrine objectification and heteronomous thought: the idea that certain people by virtue of race, religion, nationality, gender or sexual preference may be denied rights to basic freedoms of action, association and thought (or even to life itself), and that the greatest ethical imperative is to follow orders. The Abu Ghraib pictures represent a moral universe in which people are used as mere (disposable) means to ends, the latter being the gratification of the torturer, the obtaining of information, the camaraderie of occupying forces and the coercive inscription on bodies and minds of national, racial and religious superiority or inferiority.

Few observers could have missed these fundamental distinctions between modern artworks and the torture images – indeed, they were often the reason for making the comparison. But like comparison of the photographs with classical (or classically inspired) paintings and sculptures, the differences modern art and the torture photographs have been strangely absent from critical discussions. Indeed, after the initial flurry of attention in the mass media in 2004, the Abu Ghraib pictures themselves – as compared

to the issues surrounding US torture – have been the subject of very little serious consideration, contributing to a pervasive sense of helplessness before the growing visual record of cruelties perpetrated in the name of American and British citizens. This book addresses that critical aporia and proposes an interpretation of the photographs attuned to the historical development of European art and imagery, and modern popular culture. It interrogates the manner in which images of torture, power and domination are passed down from one generation to the next, and how such pictures come to be widely embedded in both visual memory and the physical body. By interrogating such imagery and such practices, I hope to make them less familiar, less palatable and less easily used by sovereign, imperial powers.

The photographs made in Abu Ghraib prison – at once disturbing and familiar in their form and content, demanding yet somehow denying interpretation – conjure a perceptual and imaginative realm that Sigmund Freud called *unheimlich*, or uncanny. The subject and title of his celebrated essay of 1925, the uncanny is a term in aesthetics as well as psychology; it is both the designation of a striking artistic or literary effect (employed for example in the nineteenth century by the short story writers E. T. A. Hoffmann and Edgar Allan Poe), and the feeling that arises as the consequence of a perturbation of mind. Such disturbance – sometimes a symptom of profound mental derangement and sometimes a mere shadow that passes over consciousness – is caused by an obsession, compulsion or sudden shock of recognition. Particular triggers of the uncanny, Freud states, include frequent coincidences, having one's exact thoughts become real or one's wishes come true, perceiving the glance of an 'evil eye', confronting one's look-alike or double, or seeing similitude in what to everyone else is manifestly unlike. The shock of the uncanny often derives, Freud further argues, from its invocation of primal thoughts and fears, especially Oedipal desire and the dread of castration. The uncanny is a thing or event that has the capacity to congeal thoughts, disorient the senses and occlude reason. It may be experienced at any time, and indeed is all the more vivid when least anticipated. 'The uncanny', Freud writes, 'is something that

was long familiar [*heimlich/heimisch*] to the psyche and was estranged from it only through being repressed'.[7]

On seeing the photographs from Abu Ghraib prison, many critics, art historians and others experienced the disorientation of the uncanny because they saw in the hierarchic disposition of bodies, the mock-erotic scenarios, and the expressions of triumphant glee on the faces of the captors, something that was disturbing and intensely familiar, but could not be named or fully recalled to consciousness. What they recognized but quickly forgot – in a process akin to what Freud in an earlier text called 'parapraxis' – is in fact a key element of the classical tradition in art that extends back more than 2,500 years, at least to the age of Athens. It is an element seen in the equipoise of the animals led to slaughter on the Pan-Athenaic frieze; in the cruelty of the Battle of Gods and Giants on the Pergamon Altar; in the anti-Islamic zeal of a fresco by Raphael in the Vatican Palace; in the morbid eroticism of a marble slave (and the crucified Hamen painted on the Sistine Chapel ceiling) by Michelangelo; and in the exquisite anguish of a colossal, sculpted saint by Bernini in St Peter's Basilica. And it thrives today – often in odd and etiolated form – in American popular media. That feature of the Western classical tradition is specifically the motif of tortured people and tormented animals who appear to sanction their own abuse, which I call, after the early twentieth-century art historian Aby Warburg, a *Pathosformel* ('pathos formula'). It is the sign of what the art historian O. K. Werckmeister has called 'the introversion of ideology into feeling', that is, the physiognomic traces of internalized subordination.[8] It is the mark of reification in extremis because it represents the body as something willingly alienated by the victim (even to the point of death) for the sake of the pleasure and aggrandizement of the oppressor. This mythic motif constitutes an unacknowledged basis of the unity of the classical tradition in European or Western art. This unity, however, is generally conveyed by means of a fable (told to generations of students in college textbooks and survey classes, and addressed here in the Afterword): the apotheosizing of the human spirit in the art masterpiece.

The pathos formula described here endured – with considerable variations – from ancient times to the mid-nineteenth century, disappeared from at least one part of European and American artistic and cultural production (the modernist avant-garde) during the late nineteenth and twentieth centuries, and reappeared refulgent with the rise of fascism. It infected industrial or mass culture in the middle and later part of the last century, and was then bestowed by state bureaucrats, military officers and the culture industry, like a malediction, on the visual imaginations of the morally wounded souls who police the dungeons of the US imperium. What the photographs from Abu Ghraib therefore also reveal, and what most commentators – stricken by the shock of the uncanny – forget (or wish to deny), is the perfectly unexceptional character of the images in the history of European and American representation, as well as the equally unexceptional fact of US torture, practised throughout its history, from the Indian territories of the Continental West to Vietnam, from the police stations of Chicago to the concentration camp at Guantanamo Bay in Cuba.[9]

The photographs of torture at Abu Ghraib prison can be seen as the product, in the words of Warburg, of a 'heritage stored in the memory'.[10] They are the expression of a malevolent vision in which military victors are not just powerful, but omnipotent, and the conquered are not just subordinate, but abject and even inhuman. The presence of the latter, according to this brutal perspective, gives justification to the former; the supposed bestiality of the victim justifies the crushing violence of the oppressor. Or as Michael Taussig writes, in addressing the tortures administered by agents of the Argentine junta during the Dirty War (1976–83): 'The military and the new Right, like the conquerors of old, discover the evil they have imputed to these aliens, and mimic the savagery they have imputed.'[11] The US State Department (then led by Henry Kissinger), which sanctioned the violence in Argentina, has embraced the same principle in Iraq, Afghanistan and indeed the rest of the theatre of the global war on terror.[12] In doing so, it has drawn on an ancient pathos formula represented in classical art, providing soldiers and civilians with some of the most vicious weapons in their arsenal.

2

Freudian Slip

The reactions of most art historians and critics in the United States and elsewhere to the photographs of tortured prisoners at Abu Ghraib may be summarized as fright and familiarity.[1] The fright is easy to grasp and explain. The extrajudicial seizure, imprisonment, torture and murder of people shocks and horrifies any vital conscience. The contravention of international agreements on the treatment of prisoners of war, as well as the wanton violation of US civil and military regulation – without check by legislative or judicial branches of government – shatters one of the most basic and sustaining tenets of US constitutional democracy: the separation of powers and the vulnerability of the executive to sanctions provided by the rule of law. The demonizing of non-white, non-Christian populations through the use of Manichean language – the 'Axis of Evil', the 'evil-doers' and so on – revives an Orientalism and racism that generations of religious, educational and political leaders have sought to dismantle. The marshalling of crude stereotypes of women, homosexuals and animals – apparent when Muslim men are made to wear women's underwear, mime gay orgies, and be led on leashes – signals the presence among military and civilian authorities of a vicious sexism and homophobia. Finally, the combination of all these elements, together with the transformation of public policy itself into spectacle – what the critic and philosopher Walter Benjamin called the aestheticizing of politics – suggests the existence of an incipient authoritarianism. Under a regime of fascism, Benjamin writes, 'self-alienation has reached such a degree that it can experience its own destruction as

an aesthetic pleasure of the first order'.[2] The photographs of torture at Abu Ghraib are frightening not just because of what they reveal about US treatment of Iraqi prisoners, but because of what they disclose about the current political scene: the auto-demolition of the ideal of democracy.

But there has been another response besides fright, among critical observers of the photographs of Abu Ghraib, one that requires more detailed examination because it is in many ways so surprising, given the disturbing character and exotic context of the images: that is, familiarity. In the days and weeks after the revelation, on 4 May 2004, of the photographs of tortured Iraqis on *60 Minutes II* and their subsequent worldwide dissemination, many observers remarked that the pictures called to mind works by certain well-known, politically engaged artists of the past two centuries.[3] Among these are Francisco Goya, creator of the *Third of May, 1808* (illus. 3), the central figure of which – a man with arms outstretched as if crucified, shown moments before his murder by firing squad – seemed to prefigure a number of the photographs, including that of the pathetic, hooded Iraqi made to stand on a C-ration box (in 'stress position') with arms wide, wires dangling from his body (illus. 2).[4] The celebrated painting in the Prado was Goya's public, retrospective paean to the resistance of the Spanish pueblo to the invading armies of Napoleonic France. It suggested that the six years (1808–14) prior to the restoration of Ferdinand VII were a period of heroic struggle and Christian sacrifice, and that the coming epoch promised redemption, that is, a new national unity, guaranteed by personal, expressive, and press freedom and a government of laws. Soon Goya would discover that the horror had not ended, and that Ferdinand's goal was nothing less than to extinguish the light of reason itself. The artist's private answer to that crime and that horror was the nightmarish *Les Desastres de la Guerra* ('The Disasters of War', 1810–13). But in the generations that followed the artist's death in 1824, *Third of May, 1808*, along with his suppressed suites of etchings called *Los Caprichos* (1799) and *Disasters*, the *Inquisition Album* and numerous other works, were understood and used as weapons against ignorance, injustice and inhuman cruelty. Today, *Third of May, 1808*, like Picasso's

Guernica (discussed below), is veritably an anti-war icon, invoked, reproduced – and sometime abused – whenever men and women wish to protest a new military or imperial crime, abuse or indignity.

The drawings in the *Inquisition Album* are Goya's responses to the panoply of tortures long sanctioned by the Holy Office in Spain, the tribunal established in 1481 and dedicated to the enforcement of Catholic doctrinal orthodoxy, the suppression of heresy and dissent and the enrichment of the clergy and crown. In about 15 drawings, the artist recorded his satisfaction or hope – perhaps prompted by the fragile constitutional interlude of 1812–14 – that support for the Inquisition was waning, and that brutality would at last be recognized for what it was.[5] In other works as well, including the drawing (preparatory for an etching of the same title) *The Custody of a Criminal Does Not Call for Torture* (illus. 4), a comparable reformist zeal is manifest. This drawing depicts a single figure, propped against a wall at right, with torso bent at the waist, bare legs rigid, ankles chained and arms manacled behind him. His head is slumped forward so that just its top is visible, and to the left is a heavy grate through which enters the only light the prisoner will ever see. Such indefinite and cruel incarcerations became frequent during the furious anti-liberal purges of Ferdinand VII, restored to power in 1814 after the deposition of Joseph Bonaparte.[6]

This last work, and the others like it, including the etching *The Captivity is as Barbarous as the Crime* (illus. 5), were inspired both by revulsion at the practices of torture in Spain, and by the reformist ideals of, among others, the Italian Enlightenment philosopher Cesare Beccaria, author of *On Crimes and Punishments* (1764), who wrote: 'For a punishment to attain its end, the evil which it inflicts has only to exceed the advantage derivable from the crime; in this excess of evil one should include the certainty of punishment and the loss of the good which the crime might have produced. All beyond this is superfluous and for that reason tyrannical.'[7] Goya's print represents that tyranny as an isolating and oppressive gloom that threatens to engulf and destroy the manacled prisoner. In combination with Goya's inscribed title, the print, like the drawing *The Custody of a Criminal Does Not Call*

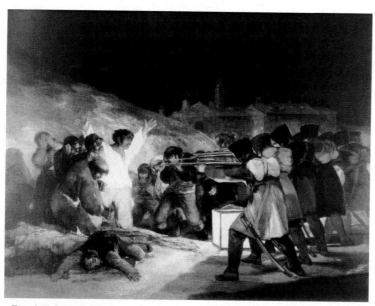

3 Francisco Goya, *Third of May, 1808*, 1814, oil on canvas.

for Torture, is a vivid condemnation of physical constraint, sensory deprivation and long-term or indefinite imprisonment.

The photographs from Abu Ghraib also recalled certain works by Picasso to the minds of writers, critics and artists, such as his etching with aquatint *The Dream and Lie of Franco* (1937) and the contemporaneous painting *Guernica*.[8] The former, begun in January and finished in June 1937, consisted of two plates, each with a sequence of nine, cartoon-like vignettes, depicting the Spanish dictator Francisco Franco ('el Caudillo') as a vainglorious midget who wreaks destruction and death wherever he goes. It was sold at the Spanish Pavilion of the Paris International Exposition in the summer of 1937; postcard-sized reproductions of the print were given away for free. *Guernica* (illus. 6), a mural-sized work first exhibited at the same Spanish Pavilion, was intended to expose and protest the bombing by the German air force of the defenceless Basque town of that name on 26 April 1937. This atrocity occurred during the Spanish Civil War and destroyed more than one third of the town, a historic centre of

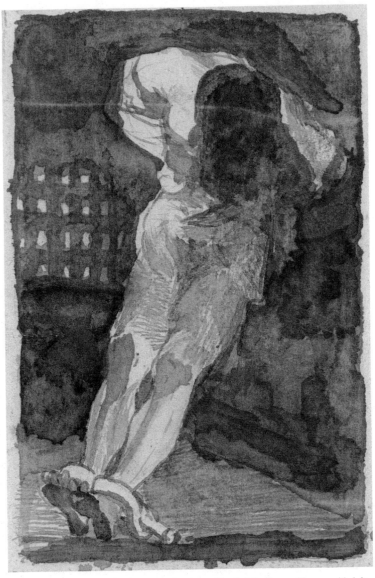

4 Francisco Goya, *The Custody of a Criminal Does Not Call for Torture* ('La seguridad de un reo no exige tormento'), *c.* 1810–14, brown ink and brush drawing.

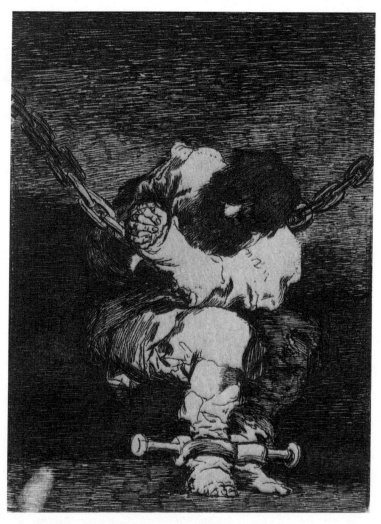

5 Francisco Goya, *The Captivity is as Barbarous as the Crime* ('Tan barbara le seguridad como el delito') , 1810–14, etching.

Basque identity and a symbol of Spanish resistance to Franco's Nationalist forces. The attack killed more than 1600 civilians, and due to Picasso's pictorial condemnation was considered – prior to World War II – the most notorious war crime of the twentieth century. The helplessness and abjection of the suffering figures and

animals in Picasso's work has been seen as anticipating the expressions of despair and fear on the faces of the victims photographed at Abu Ghraib.[9] The widely-reported concealment in early February 2003 of a tapestry version of *Guernica* at the entrance to the Security Council of the UN reminded the international public of the strength of Picasso's indictment of Franco and fascist militarism. US State Department officials apparently felt it was inappropriate for Colin Powell and UN Ambassador John Negroponte to be photographed in front of the tapestry on the day they presented mendacious testimony concerning Iraqi mobile weapons labs and weapons of mass destruction. During the mass protests in New York, London and elsewhere following the US invasion of Iraq, marchers regularly carried banners, signs or puppets reproducing *Guernica*.

The work of other modern artists too have been invoked by critics discussing the Abu Ghraib images, including Francis Bacon and Ben Shahn.[10] In paintings like *Study for Crouching Nude* (1952), Bacon referenced pornography, violence and excrement, all of which were in fact marshalled by regular Army, Military Intelligence, Military Police, CIA and independent military contractors during interrogations (and as part of daily routine) at Abu Ghraib from the summer of 2003 to the spring of 2004, and perhaps still to this day. Bacon-esque degradation is visible in a number of the photographs from Abu Ghraib, especially those depicting a man that guards and CID (Criminal Investigation Command) officials described as mentally deranged, smeared with excrement and walking naked in a corridor between cells (illus. 7). He may in fact be performing the 'walk and turn' (WAT), employed by police to test for a driver's sobriety, here used by Charles Graner (a former civilian prison guard) to mock and degrade his charge.

Ben Shahn's depiction of a handcuffed and hooded prisoner in his famous poster *This is Nazi Brutality* (illus. 8) has been taken as another precedent for the images from Abu Ghraib.[11] It was the basis for the cover of an issue of *The Nation* in 2005 devoted to what *The Nation* called 'The Torture Complex', the vast US infrastructure that enables torture in Iraq (illus. 9). In

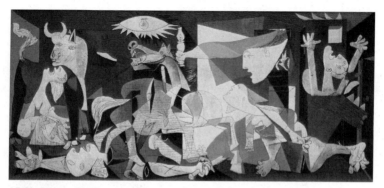

6 Pablo Picasso, *Guernica*, 1937, oil on canvas.

Shahn's work, published by the US Government Printing Office
for the Office of War Information, the artist exposed part of the
twentieth-century history of sensory deprivation techniques
now regularly used by the US military in Iraq and elsewhere as
means of restraint and torture. Nazi doctors experimented with
sensory deprivation, including hooding, as did the British in
their campaign against the IRA in Ulster in the early 1970s.[12]
The International Committee of the Red Cross (ICRC) specifi -
cally identified hooding – generally with hessian (jute, burlap)
bags – as a practice used extensively at Abu Ghraib, as well as
at Guantanamo Bay and at the Bagram Collection Point on the
Bagram Air Base, near Charikar in Parvan, Afghanistan. The ICRC
defined it as follows, noting that it was generally used in Iraq,
at Guantanamo Bay and elsewhere in combination with other
techniques, enumerated below, that the ICRC considered equally
brutal:

> 1. Hooding, used to prevent people from seeing and to dis-
> orient [prisoners], and also to prevent them from breathing
> freely. One or sometimes two bags, sometimes with an elastic
> blindfold over the eyes which, when slipped down, further
> impeded proper breathing. Hooding was sometimes used in
> conjunction with beatings thus increasing anxiety as to when
> blows would come. The practice of hooding also allowed
> the interrogators to remain anonymous and thus to act with

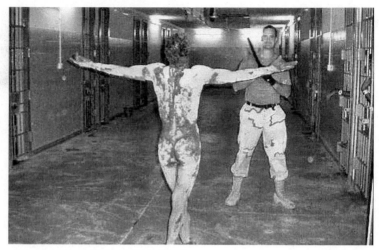

7 Prisoner known as 'Shitboy' at Abu Ghraib, 2003.

impunity. Hooding could last for periods from a few hours to up to two to four consecutive days;

2. Handcuffing with flexi-cuffs, which were sometimes made so tight and used for such extended periods that they caused skin lesions and long-term after-effects on the hands (nerve damage), as observed by the ICRC;

3. Beatings with hard objects (including pistols and rifles), slapping, punching, kicking with knees or feet on various parts of the body (legs, sides, lower back, groin);

4. Being paraded naked outside cells in front of other persons deprived of their liberty, and guards, sometimes hooded or with women's underwear over the head;

5. Being attached repeatedly over several days . . . with handcuffs to the bars of their cell door in humiliating (i.e. naked or in underwear) and/or uncomfortable position causing physical pain;

6. Exposure while hooded to loud noise or music, prolonged exposure while hooded to the sun over several hours, including during the hottest time of the day when temperatures could reach 122 degrees Fahrenheit . . . or higher;

7. Being forced to remain for prolonged periods in stress

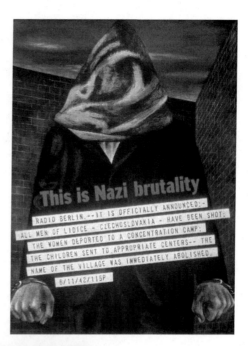

8 Ben Shahn, *This is Nazi Brutality*, 1942, offset litho poster.

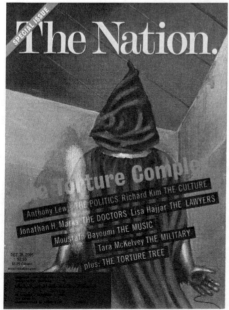

9 Steve and Janna Brower (after Ben Shahn), cover of *The Nation*, 26 December 2005.

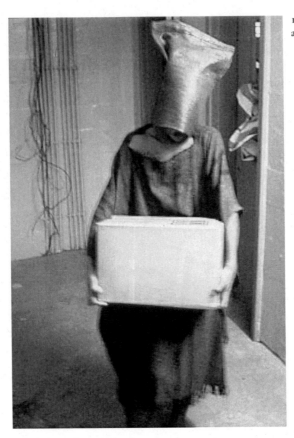

positions such as squatting or standing with or without the arms lifted.[13]

Shahn's poster is salient in discussions about Abu Ghraib and the war against Iraq for an additional reason: his association of the hooding of prisoners with the elimination of their human and social identity reminds us of similar practices by US troops. Just as the name and face of the man in Shahn's image are hidden from us, so the man's town – Lidice in Czechoslovakia (now the Czech Republic) – was erased by Nazi brutality through demolitions, mass executions and deportations.[14] The US military operating in Iraq, as far as we know, has no *Einsatzgruppen* or task

forces that function as mobile execution units, but they have undertaken assassinations of suspected, putative terrorists, as well as collective reprisals against the towns of Fallujah, Samarra and others in Western Iraq near the Syrian border for allegedly harbouring Sunni insurgents opposed to the occupation.[15] The towns were decimated by ground and aerial bombardment in 2004 (including the use of chemical weapons), and large numbers of residents were either arrested or forced to become refugees.[16] By November 2004 the number of internally displaced persons (IDPs) in Iraq, according to the United Nations High Commission for Refugees (UNHCR) had reached 400,000 largely as the result of the massive evacuation from Falluja.[17] In addition, much of the torture at Abu Ghraib was intended to so dishonour the victims that return to their communities would be impossible.

Stripping men of their clothes, dressing them in women's underwear, forcing them to masturbate and then photographing them, were abuses specifically designed by US intelligence officials to grossly offend Muslim sensibilities. In Iraq as elsewhere in the Islamic world, the spaces of the home, the precincts of the body and the recesses of the mind are considered private and inviolate, especially to strangers or others who do not observe the rules of *halal* or religious purity. For this reason, highly observant Muslim men tend to be extremely modest in their speech and behaviour toward non-Muslims, and generally go to great lengths to preserve from public view their core attitudes, feelings and beliefs. By the same token, they themselves accept the religious injunction – contained in the Quran and modern interpretive texts – to avert their gazes from the faces of unrelated women and from the naked bodies of people with whom they are not affiliated. Though the viewing of pornography is undoubtedly extremely widespread in the Islamic world today, it is generally expressly forbidden (*haraam*) by law and custom, and religious authorities cite numerous passages in the Quran forbidding lewdness.[18] Thus the frequent nakedness of the detainees at Abu Ghraib, their forced proximity to other naked inmates and to guards – particularly female guards – was an engineered assault on Islamic culture and religion as well as an insult to individual Muslim men and women.

To then also photograph the prisoners in this context was profoundly alienating, isolating and shaming. Both these forms of abuse: the intended eradication of whole communities through collective reprisal and the shaming of individuals and families are instances of the demonizing of a civilian population, invoked by the anti-Nazi poster of Ben Shahn, and practised by the US Military in Iraq.

It was a logical place for criticism to begin, then: with Goya's *Third of May, 1808* and *Inquisition Album*, Picasso's *Guernica* and Shahn's *This is Nazi Brutality*. They are iconic images in multiple senses of the word: searing, unforgettable and venerated. They are widely seen as tokens of artistic genius and moral responsibility, and they illuminate the brutality of the US war against Iraq. But art-historical discussion of the relationship between these or other modern works of art, and the prison pictures from Abu Ghraib, has been at best brief and insubstantial, a matter of short newspaper and magazine articles, postings on blogs and in webzines, popular lectures, symposium banter and art history department or museum office conversation. No one has addressed in any depth or with any specificity what is actually depicted in the photographs, that is, their basic organization of bodies and *mise en scène*. Nor has anyone carefully considered their place within the history of Western popular representations of torture, sex, captivity and pain, as represented in public and private photographs, prints, posters, advertisements, films, video and television.

The only significant exception to this absence is the early and still frequent comparison of the Abu Ghraib pictures with pornographic images and photographs of lynching. Some writers – allied with law professor, and anti-pornography crusader Catharine A. MacKinnon – equated the Abu Ghraib photographs with pornography, claiming that each represented sexual coercion and violence.[19] If an American is to register outrage at the sexual abuse of prisoners at Abu Ghraib thousands of miles away, one argument went, an equal indignation ought to be expressed about the daily torture of women working in the multi-billion dollar pornography industry right here in the United States.[20] Women

in pornographic videos are prisoners too, claimed Susan Brison in the *San Francisco Chronicle* in July 2004, regularly blackmailed, shamed, bribed and even abducted into the business.[21] Rochelle Gurstein went so far as to assert in *The New Republic* that pornography could be the proximate cause of the torture at Abu Ghraib. Citing MacKinnon and Andrea Dworkin, she argued that accused (later convicted) torturer Lynndie England was herself a victim of pornography and therefore should not be found culpable of prisoner abuse:

> England's sadism, along with the fact that she and [Charles] Graner not only made but circulated pornographic videos of themselves, speak to the coercive and brutalizing nature of the pornographic imagination so prevalent in our world today . . . Pathetic Lynndie England, shown in a[n] article awkwardly cradling her infant boy (her child with Graner, who is now married to another woman involved in Abu Ghraib) – here, I thought, was the Linda Lovelace [star of *Deep Throat* and later anti-porn activist] of our times.[22]

Arthur Danto's position, presented in the pages of *Artforum* the same month Brison's essay appeared, similarly compared pornography and the torture pictures. He wrote: 'The images show the degree to which American consciousness has been penetrated by the imagery of pornography. But so has world consciousness, given the ubiquity of videotapes that deal with images of sexual bondage and humiliation.' For Danto, the pictures from Abu Ghraib were examples of the same 'democratization of despotic fantasy' that is manifested by the 'wholesale manufacture and distribution of sado-masochistic pornography'.[23] In his short essay Danto did not discuss any specific sado-masochistic movies, provide evidence that the soldiers, officers or civilians at Abu Ghraib had actually seen any, or indicate how, if they had, such movies might have prompted these men and women to act in the ways they did.

Slavo Zizek too addressed pornography (albeit of an art-world kind) in an essay published soon after the appearance of the

photographs, comparing the image of the hooded man forced to stand on a box to works of performance art, 'scenes from David Lynch movies', and photographs by Robert Mapplethorpe (illus. 11), arguing that it exposed 'the obscene underside of US popular culture'.[24] For Zizek (here appearing to echo the anti-pornography zeal of Catherine MacKinnon), the revelations contained in the photographs (illus. 12) are not so much that the US has openly given sanction and cover for torture, but that it has perversely provisioned Iraqi prisoners with 'a taste of the obscenity that counterpoints the public values of personal dignity, democracy and freedom'. Thus Danto and Zizek come very close to blaming pornography and the S/M subculture for the obscenity of government sanctioned torture.

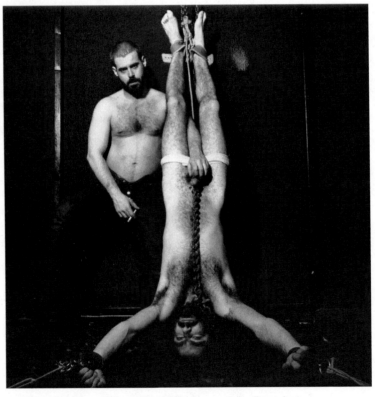

11 Robert Mapplethorpe, *Dominick and Elliot*, 1979, gelatin-silver print.

12 Unknown Iraqi man, Abu Ghraib, 2003.

Whatever the superficial similarities, there are enormous differences between industrially produced pornographic pictures and videos – whether sado-masochistic or 'vanilla' (depicting conventional sexual behaviour) – and the digital snapshots and short videos from Abu Ghraib.[25] To begin with the most obvious,

the former are the legal creations of independent producers, directors, writers, actors and cameramen, while the latter are documents showing indisputably illegal acts of abuse and torture perpetrated by soldiers, military police and civilians on clearly unwilling victims at the behest of their superiors in the Iraqi theatre of operation and elsewhere (including Washington, DC). Moreover, sado-masochistic acts themselves (now usually referred to by their practitioners as Bondage/Discipline/Sadism/ Masochism, or BDSM) and its concomitant pornography must be considered critical inversions – not compliant iterations – of the scene of torture. BDSM, according to its adepts, transforms the postures, actions and rhetoric of institutionalized violence into a ritualized, privatized and carefully orchestrated costume drama of intimacy, pleasure and mutuality. In actual torture, no safe-words can be used to stop the tormentor from pressing his advantage to the point of excruciating pain or even death. At Abu Ghraib, the chain around a Muslim inmate's neck, attached to a leash held by Lynndie England (illus. 13), is not a BDSM collar, shared symbol of a long-term emotional and erotic bond between the dominant and the submissive partner; it is the expression of the complete emotional alienation of master and slave.

In addition, the crudely artisanal, Abu Ghraib photographs, unlike highly finished, even culinary, industrial sex-videos, were

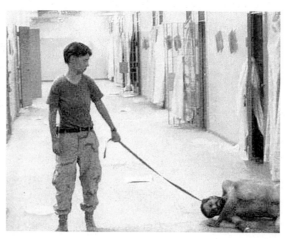

13 Spc. Lynndie England and the leashed prisoner known as 'Gus' at Abu Ghraib, 2003.

never intended by their producers to be publicly released. They were instead made to be shared among fellow prison guards, their friends and family, as well as shown to the torture victims themselves for the purpose of inducing feelings of shame and degradation. As such, there is no reason to believe that they were intended for erotic delectation or titillation. Though their subject is often sex – BDSM scenarios, masturbation, oral sex, exhibitionism and voyeurism – there is nothing sexy about them. The hooded Iraqi men in the masturbation video, mechanically tugging and stroking, or the mock fellatio photographs (illus. 14 and 15) are not (for obvious reasons) aroused, violating one of the key rules in pornography: no flaccid penises. Indeed, the mimetic quality of pornography – its essential function as a surface of erotic projection, enabling fantasy and sexual arousal – is clearly not paramount in the case of the Abu Ghraib pictures.[26] They are instead about the vehement assertion of difference, not the discovery of sameness; they expose an imperialist mockery, not colonial mimicry.[27] The only possible exception to this is the photograph of an Iraqi woman prisoner made to lift her blouse to expose her breasts (illus. 16 and 17). These pictures however, part of a series depicting two female detainees made in late October 2003 and released to the press two years after the initial publication of the Abu Ghraib images, recalls not pornography but the literally sophomoric, 'soft-core' pornographic video franchise identified with the catch-phrase 'Girls Gone Wild', which generally depicts college-age women at various venues – on campus, during Spring Break, at Mardi Gras, and so on – showing off their breasts and buttocks, kissing, sometimes briefly masturbating and generally teasing and flirting. If indeed the guards at Abu Ghraib have watched and emulated these videos, they have transformed scenes of crude, but convivial burlesque into images of debasement and physical and psychological isolation.

Luc Sante, Susan Sontag, Abigail Solomon-Godeau and Dora Apel all compared the Abu Ghraib images to photographs of lynching (illus. 18). In an op-ed piece in the *New York Times* that appeared just a week after the CBS broadcast of the images in May 2004, Sante argued that the pictures, like lynching post-

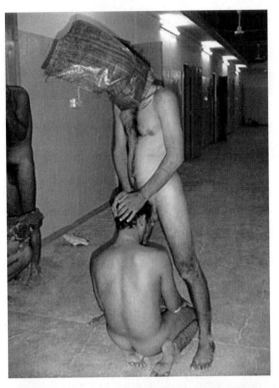

14 Unknown Iraqi prisoners at Abu Ghraib, 2003.

15 Video still of an unknown prisoner being forced to simulate masturbation, Abu Ghraib, 2003.

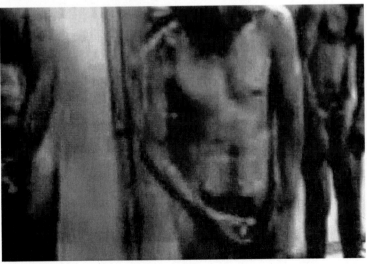

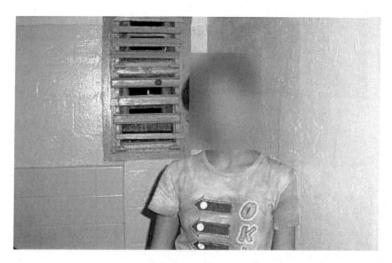

16, 17
Unknown Iraqi
woman, Abu Ghraib,
2003.

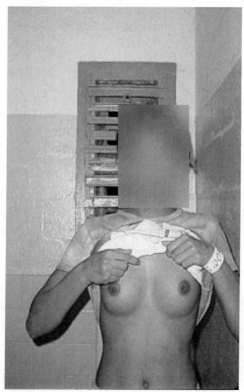

cards from the early twentieth century, functioned as trophies, exposing both the racism of the perpetrators – soldiers and civilians alike – and their sense of impunity.[28] Sontag, writing in the *New York Times Magazine* a few weeks later, also invoked the lynching postcards, stating: 'The lynching photographs were souvenirs of a collective action whose participants felt perfectly justified in what they had done. So are the pictures from Abu Ghraib.'[29] She added that most of the pictures from Iraq have a sexual theme, or at least sub-current, 'inspired by the vast repertory of pornographic imagery available on the internet – and which ordinary people, by sending out webcasts of themselves, try to emulate'. Finally, Sontag writes, 'the pictures are us', our racism, our love of violence and our imperial shamelessness. In

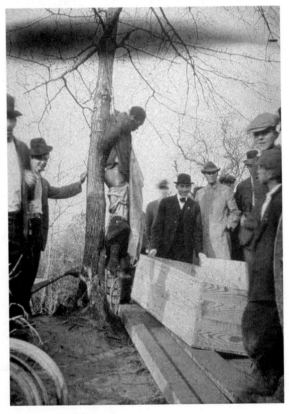

18 John Richards hanging from a tree, jubilant lynchers and a freshly hewn pine coffin, 12 January 1916, Goldsboro, North Carolina, gelatin-silver print.

her essay for *Artforum*, published in 2004, Solomon-Godeau too mentioned the lynching association, but spoke more broadly about the authority of photographs – even in the age of digital manipulation – to bring about the cognition of brutal realities and stir political passions.[30] And Dora Apel has argued, in an essay published in 2005, that the photographs from Abu Ghraib, again like the lynching photographs, exposed a 'culture of community sanction' that dehumanizes its victims in order to uphold oppressive ideologies of race and nation; 'torture', she writes, 'is a fundamentally political act'.[31]

In highlighting the themes of race, nation, pornography and violence in the Abu Ghraib photographs, and asserting that rather than an aberration, the pictures expose an all-too-American history, these writers have provided a forceful critique of past and present US culture and government policy. But the frequent comparison of the Abu Ghraib pictures to lynching postcards, it seems to me, has short-circuited analysis; in the rush to assimilate the prison photographs to an earlier body of brutal American images – and thereby highlight national character and political responsibility – the specific subjects and purpose of the prison photographs themselves, and their deep historical roots, are obscured. Moreover, references to Goya, Picasso, Bacon or Ben Shahn – as apt as they at first seem – are fundamentally mistaken, though these names enter our consciousness with the ineluctable force of a Freudian slip. For whereas the prison photographs sanction the infliction of pain and humiliation on the powerless, paintings and prints by these artists clearly condemn that victimization. Whereas the prison photographs employ putatively erotic tableaux – carefully choreographed by prison guards and photographers – in order to suggest that the prisoners were willing, even enthusiastic participants in their own incarceration and chastisement, the works of art erase any trace of a shared, erotic space in order to make plain the shame and degradation of torture. The contrast between the expressions on the faces of the torturers and victims in Goya's *Caprichos*, such as his plate 'Nothing could be done about it' (illus. 19) makes clear the emotional gulf that separates the two sides – the absence of faces in

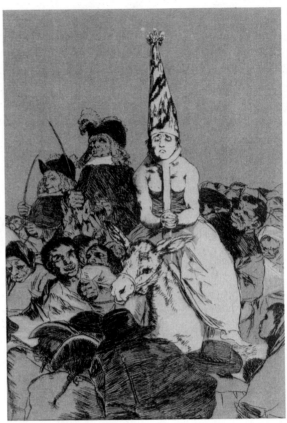

19 Francisco Goya, *Nothing Could Be Done About It* ('Nohubo remedio'): Plate 24 from the series *Los Caprichos*, 1799, etching and burnished aquatint.

many of the Abu Ghraib pictures permits the viewer to believe the prisoners were willing participants in the sexual scenarios conjured by the guards; the physiognomic and bodily disfigurement of principal figures in Picasso's *Guernica* too accentuates the unbridgeable divide between perpetrator (unseen but fully intact) and helpless subject (visible and broken); and the anonymity and abject vulnerability of the hooded figure in Shahn's poster denies the possibility of human interchange or community. The cloaked bodies in the examples by Goya, Picasso and Shahn, compared to the nakedness of the figures in the recent torture photographs (illus. 20) also underscores the profound distance between them. Indeed, the difference between the two groups of images – those

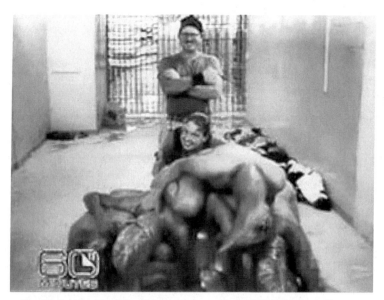

20 Spc. Charles Graner and Spc. Sabrina Harman posing with Iraqi prisoners, Abu Ghraib, 2003.

from Abu Ghraib, in which guards preside over a coerced and joyless gay baccanal, and those by modern artists regularly cited in association with the torture photographs – could not be starker, and that fact is clear to us upon even a moment's reflection.

3
Documents of Barbarism

The insufficiency of art-historical explanations of the torture photographs from Abu Ghraib is the paradoxical consequence, it seems to me, of their very centrality in the art historical tradition. Their origin and significance in other words, is hidden in plain sight.[1] Recall here the *locus classicus* of art-historical overlooking and mis-remembering: Freud's essay of 1901, 'The Forgetting of Proper Names', from the *Psychopathology of Everyday Life*. In this text we read of the young analyst's vacation travels by carriage on the Adriatic coast in the company of an older gentleman from Berlin. Perhaps seeking to impress his companion with his sophistication, Freud describes a previous vacation he had taken in Italy, and visits to various historic towns, including one, Orvieto, which especially struck him. At this point, however, as Freud recounts, he could not remember the name of the artist who painted the great *Last Judgment* in Orvieto Cathedral (illus. 21).[2] He had attended to it very carefully at the time, and could still recall many large and small details of the work, but try as he might, he could not summon the name of its creator. Instead, the names Botticelli and Boltraffio repeatedly entered his consciousness, though he knew at once that neither of these could have been the artist. It was only a few months later, when he met an Italian of some erudition that he recovered the correct name – it was, of course, Signorelli. Freud's analysis of his forgetfulness would become for him the signal example of 'parapraxis', an error of speech or slip of the tongue that reveals a repressed truth. This particular mistake, Freud wrote, arose from his repression of disturbing news

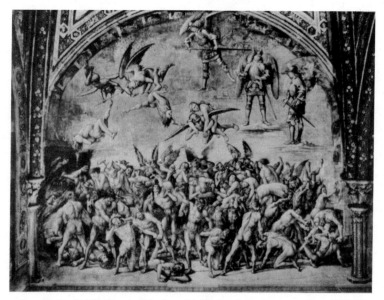

21 Luca Signorelli, 'The Damned', in the series *The Last Judgment*, *c*, 1503, fresco, S. Brizio Chapel, Orvieto Cathedral.

he had recently received about a patient who had killed himself because of despair about 'an incurable sexual disorder'. The name of the place in which he heard this information about 'death and sex', Trafoi in Herzegovina, resembled that of Boltraffio, one of the remembered artists. By thus forgetting the name of the well-known late Quattrocento master Signorelli, and remembering that of the relatively obscure Milanese follower of Leonardo, Freud was at once forgetting and remembering – repressing a painful memory but at the same time recalling it to consciousness, albeit indirectly.

The Abu Ghraib pictures have also prompted a parapraxis; the recall of a few exceptional, and mostly modern, works of art – by Goya, Picasso, Shahn and others – that condemn torture, imprisonment and fascism, in place of the much larger set of canonical artworks that are in fact consonant with the form and meaning of the Abu Ghraib photographs. This latter assembly of artworks, possessing a common mythic structure or – using an alternative vocabulary – a 'pathos formula', constitute a tradition

that extends from Hellenistic times to our own; it is in-dissociable, I would claim, from the history and practice of art history as a discipline, and is what is repressed when we summon up the names Goya and Bacon, or when we recall only pornography and lynching pictures. The photographs made by soldiers, MPs and civilians at Abu Ghraib – which by their deployment of sexualized scenarios depict torture as if it were something erotic, or at least potentially pleasurable for the victims – are not exceptional images in the history of Western visual culture, they are the rule.

Here I turn for illumination from Freud to Walter Benjamin, who identified better than anyone else the bad conscience, or repressed memory, of art history. In 1940, while in flight from Nazism, Benjamin, as is well known, composed his *Theses on the Philosophy of History*. 'Thesis VII', the best remembered of these epigrammatic texts, addressed the critical responsibility of the historian:

> Whoever before now has walked in victory, marches in the same triumphal procession that carries today's rulers over the prostrate. The booty, as has always been the custom, is also carried in this triumphal procession; it may be called cultural assets. The historical materialist must count these assets with detached observation. For whatever cultural assets he surveys, reveal to him a lineage he cannot ponder without horror. They owe their existence not only to the exertion of the great geniuses who have created them, but also to the nameless toil of their contemporaries. There are no documents of civilization that are not equally documents of barbarism. And just as they are not free of barbarism in and of themselves, neither is the tradition whereby they are handed down from one owner to the next. Thus the historical materialist resists tradition as much as circumstances will allow.[3]

Benjamin had a number of works of art in mind when he wrote about the lineage of barbarism in his 'Thesis VII', but one was undoubtedly the Pergamon Altar, from a temple and sanctuary built in Asia Minor between *c.* 180 and 150 BCE by the

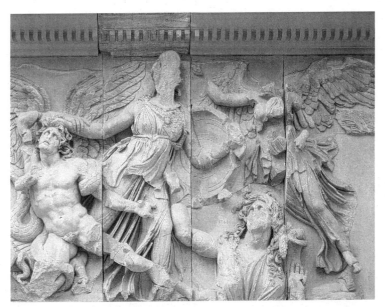

22 East frieze, Alkyoneus, Athena, Ge and Nike, Great Altar of Pergamon, *c.* 180–150 BC, marble relief.

Attalid King Eumenenes II. The site was excavated by German archaeologists in the 1880s and '90s, and reassembled in the early twentieth century in the specially designed Pergamon Museum in Berlin, Benjamin's home city. One section of the nearly 400-foot-long frieze (illus. 22) shows a giant of human origin, Alkyoneus, swooning in ecstasy and pain from the bite of a poisonous snake as he is seized and further tormented by the goddess Athena. At lower right, Ge, the mother of the giants, emerges from the ground; her anguished expression reveals her certain knowledge that her children will be tortured and killed so that the twelve principal gods of Olympos may continue to rule, unhindered by the insurgent mortals.

The point of the frieze at Pergamon was to celebrate the already omnipotent victors in the struggle between gods (who represent reason) and mortals (who represent nature or barbarism); it was also to assert that the torture and death of the latter are often necessary to ensure order and just rule. Though the depicted scenarios are not erotic, they are made beautiful. Few Greeks would

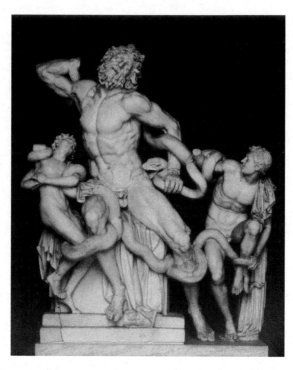

have felt sympathy for the Pergamene Giants, any more than they would for the Trojan priest Laokoon, represented in the famous sculptural group, torn apart by serpents for having affronted Athena by warning his countrymen about 'Greeks bearing gifts' (illus. 23).[4] Indeed, according to the story, Laokoon's death confirmed for the Trojans the sincerity of the Greek gift, for no man would have so succumbed to torture had he been telling the truth. The Greek word for torture, *basanos*, is also that for 'touch-stone' – the black stone against which silver and gold are rubbed to test authenticity – indicating that the Greeks considered chastisement and cruelty a necessary means to arrive at truth.[5] The word *basanos* appears frequently in writings by Attic authors from Herodotus to Aristophanes, alternately suggesting a test of wisdom (Michel Foucault writes that Socrates was a 'basanic' interlocutor) and the actual practice of torture.[6] In fact, physical torture was commonly used – or threatened to be used – to extract truthful

testimony from slaves, non-citizens or certain foreigners. Demosthenes argued that the torture of slaves elicited unimpeachable evidence, the equal of that given by free men.[7] Aristotle was less certain. Though he believed that slaves lacked the capacity of reason and thus could not be expected to tell the truth, he also believed that some might lie to stop their pain, while others – 'slow-witted and thick skinned' – might hold out indefinitely.[8]

Antiphon too was dubious about the value of testimony under torture, and there is some evidence that the forensic may have been more important than the actual use of torture for routine interrogation in civil or criminal disputes, that is, the threat of torture may have obviated its use.[9] A citizen offering up his slaves to be tortured was making a strong rhetorical claim for his side in a conflict, thus rendering actual *basanos* with a whip or the rack (the most frequent means of persecution) unnecessary. But it is nevertheless certain that torture was considered an important resource for the extraction of truth from individuals – slaves, non-Greeks, barbarians, women – who were otherwise incapable of testifying honestly. And it was regularly employed in political and military trials and interrogations, as Thucydides makes clear in his *History of the Pelopennesian Wars*.[10] *Basanos* was also the subject of an episode in Aristophanes' comedy *The Frogs*, which describes the trial by torture of Dionysos by Aeacus, doorman of Hades. In the play, the slave Xanthius offers up his master Dionysos (dressed as a slave) for torture in order to prove his own innocence of thievery:

XANTHIUS
. . . And now I'll make you a right noble offer:
Arrest my lad: torture him as you will,
And if you find I'm guilty, take and kill me.

AEACUS
Torture him, how?

XANTHIUS
In any mode you please.
Pile bricks upon him: stuff his nose with acid:

Flay, rack him, hoist him; flog him with a scourge . . .

AEACUS
A fair proposal. If I strike too hard
And maim the boy, I'll make you compensation.

XANTHIUS
I shan't require it. Take him out and flog him.

AEACUS
Nay, but I'll do it here before your eyes.
Now then, put down the traps, and mind you speak
The truth, you fellow.

DIONYSOS
(*In agony.*) Man! don't torture ME! . . .

AEACUS
You hear him?

XANTHIUS
Hear him? Yes.
All the more reason you should flog him well.
For if he is a god, he won't perceive it.

DIONYSOS
Well, but you say that you're a god yourself.
So why not *you* be flogged as well as I?

XANTHIUS
A fair proposal. And be this the test:
Whichever of us two you first behold
Flinching or crying out – he's not the god.

Here in *The Frogs*, *basanic* interrogation is given a comic turn: the highborn and the lowly switch roles, and all participants take pleasure in the spectacle of torture.[11]

However, despite its legal sanction and literary uses, neither torture nor extravagant, eroticized violence were major themes in Athenian art of the classical age (*c.* 450–323 BCE). The Athenian

embrace of democracy, begun with the reforms of Kleisthenes in 508 BCE and accelerated with the repulsion of the Persians (480 BCE), promoted an art of rationality, secularism and arithmetic regularity, precluding the sort of expressive extremism that would characterize later – autocratic and imperial – Pergamene art. The pediments and metopes from the Temple of Zeus at Olympia (c. 470–56 BCE), containing scenes of battles between Lapiths and Centaurs and the Labours of Herakles (Hercules), provide a clear image of the hierarchy among animals, humans and gods, and more indirectly, between Greeks and barbarians, but the poise and athleticism of the various contestants indicates the autonomy of each. The artists and patrons of the Panathenaic frieze in the Parthenon at Athens also clearly promoted the subordination of animals to humans, and humans to gods, but with a restraint unlike that found in work by their Pergamene followers. Nevertheless, signs of the emerging rhetoric of internalized oppression are apparent: at the conclusion of the actual Panathenaic procession, held every four years in honour of the birthday of the goddess Athena, cattle and other animals were slaughtered by the thousands in a grotesque orgy of fire and gore,

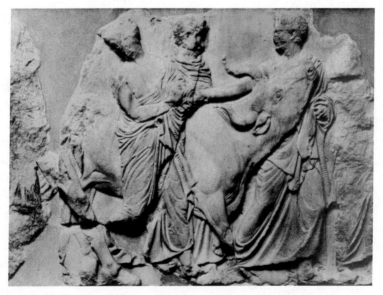

24 Youths leading cattle, Parthenon relief, c. 440 BCE, marble.

but here on the relief a single cow raises its head not in protest against its fate, but simply against its tether (illus. 24). It is not portrayed as a victim of human brutality, but as Keats wrote, a 'heifer lowing at the skies'. The last marbles of the South Frieze represent the perfect placidity of cattle being led to slaughter.

The Parthenon itself was the product of a short-lived empire, limited in geographical extent. At the height of its military and economic powers, *c.* 440 BCE, Athens received tribute from its colonies – approximately 150 Ionian cities – that greatly exceeded Attic inland revenues; this wealth made possible the signal achievements of Athenian culture, including its monumental architecture and sculpture. But Athenian imperialism was constrained by two factors.[12] First, the very democratic structure of its governance, with citizens exercising direct control over all functions of state and society, including military, political and economic affairs, made impossible the large, impersonal, bureaucratic apparatus necessary for the maintenance of authority over a far-flung empire. Second, this administrative weakness permitted the oligarchic cities of the Greek mainland, led by Sparta, to successfully challenge Athens during the long and brutal Peloponnesian Wars. By the middle of the fourth century BCE, Sparta too – its warrior elites constitutionally incapable of maintaining imperial rule – was defeated by the Thebans, who in turn formed an alliance with Philip II of Macedonia, paving the way for the establishment of the first great imperial system of the Mediter - ranean region. The Hellenistic empire succeeded in imposing as never before a single, hierarchic model of social relations, religious and philosophical belief, and political authority on a vast territory, from Greece to the Caucasus. Its syncretistic religious system – the consequence of its geographic and cultural breadth – constituted the basis of a universalism, a claim to absolute truth regardless of place or time, and a dogmatic insistence on obedience to the word of rulers and priests. In such a context, artistic imagery – as at Pergamon – was bound to instate aristocratic authority.

Though there is meagre evidence concerning torture at Pergamon, the infliction of pain on slaves and captives was sanc-

tioned by law in third century BCE Ptolemaic Egypt and elsewhere in the Hellenistic world, and given the Attalid embrace of Alexander as one of its *progonoi*, it must have been common there as well, with the artistic culture providing some proof.[13] The governing hierarchical and aesthetic system of the expansive Attalid Dynasty of King Eumenenes II – then in warfare against the Seleucids and other non-Greeks or barbarians – required that the dying giants and divine murderers on the altar alike manifest formal attributes of beauty, grace and animation. Each dance across the marble facade, limbs joined or overlapping, is a carousel of domination and suffering. By virtue of the very eloquence and sympathy of forms and by means of the very intertwining of bodies, victims appear to welcome the blows of their tormentor; the dying give thanks to their executioners. Only the victims, however, raise their eyes and brows heavenward in the universal language of

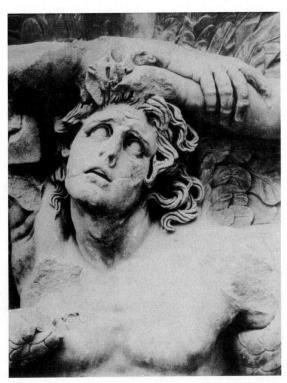

25 East frieze, Alkyoneus, Great Altar of Pergamon, *c.* 180–150, BC, marble.

supplication (illus. 25). (The ruling Attalids must have known this affect well – among the new, Hellenistic states, only Pergamon used slave-labour on its aristocratic estates, as well as in mines, industries and workshops.[14]) Truth and enlightenment at Pergamon must be enforced or tested by cruelty, torture, slavery and death. The latter are indeed necessary for the former to exist; thus even suffering and torture – *basanos* – is beautiful and must be represented as such. 'In the parts where the greatest pain is placed', wrote Winckelmann about the Laokoon, 'he shows us the greatest beauty'.[15]

This highly emotive rhetorical system is evident as well in the *Dying Celtic Trumpeter* (illus. 26) and the *Suicidal Celt and his Wife*. In these works however, the expressive extremism of the Laokoon group and Pergamon reliefs is significantly moderated. The barbarians' deaths are represented here in the philosophical language of stoicism (a system of thought that arose in Athens around 300 BCE, at the dawn of the Hellenistic era), whereby all bodily drives, impulses and passions are revealed to be mere impulses, unworthy of rational reflection. As such, they may be erased, and an ideal temperament of serenity achieved.[16] 'The entire history of emotion', the Roman Cicero wrote, 'can be summed up in a single point: that they are all in our power, all

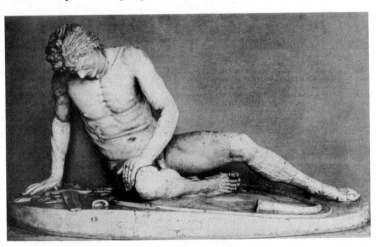

26 *Dying Celtic Trumpeter*, Roman copy of a Greek bronze original of *c.* 220 BC, marble.

experienced through judgement, all voluntary. It is . . . error then, that must be removed . . . belief that has to be taken away'.[17] For a stoic philosopher, the beauty of the *Dying Celtic Trumpeter* is a consequence of the figure's philosophical introspection, his logical choice of suicide over the humiliation of servitude.

The expressive suffering revealed in the greatest monuments of Hellenistic art marks the onset of an expressive, propagandistic tradition that would survive more than 2,000 years. Indeed, the Hellenistic aestheticizing, eroticizing and rationalizing of pain and suffering – the insistence upon the value and necessity of *basanos* – constitutes the beginning of an artistic pathos formula. That formula, clearly visible in Roman art and culture, survived in architectural sculpture of the Middle Ages, and reappeared in all its terrible splendour during the Renaissance and Baroque, even as antique laws concerning torture were themselves revived and 'the inquisitorial procedure supplanted the [medieval] accusatorial procedure'.[18]

Aby Warburg, who coined the term *Pathosformel*, provides an insight into that artistic *nachleben* (afterlife) in his essays on 'The Renewal of Pagan Antiquity'. For example, when a small replica of the Laokoon was discovered in Rome in 1488, he tells us: 'The discoverers, even before they recognized the mythological subject, were fired with spontaneous artistic enthusiasm by the striking expressiveness of the suffering figures and by '*certi gensti mirabili*' (certain wonderful gestures).'[19] Drawing on terms derived from the Renaissance historian Jacob Burckhardt and Friedrich Nietzsche, Warburg located the origin of a *Pathosformel* of 'passionate suffering' in an ill-defined, ancient time of savage ritual and Dionysian exuberance:

> It is in the region of orgiastic mass seizures that we must look for the original dye which stamps upon the memory the expressive movements of the extreme flights of emotion – as far as they can be translated into gestural language – with such intensity, that these 'engrams' [imprints] of the experience of passionate suffering persist as a heritage stored in the memory.

They become exemplars, determining the outcome shown by the artist's hand as soon as exaggerated values of expressive movement reach daylight via the artist's creativity.[20]

These artistic 'exemplars', preserved through the faculty of *mnemosyne* – the collective memory of images – possess a rationalizing and progressive energy, according to Warburg, that enables a community to overcome irrationalism and fear.[21]

The pathos formula discernible at Pergamon and elsewhere is not precisely that discussed by Warburg, who was more concerned with dynamic images of expressive mourning than with what I have called the internalization of chastisement, self-alienation, and even the eroticization of suffering. Nor is his proposal of a primordial, ritual origin of pathos formulae very persuasive. The roots of the motif examined here lie in the contingent histories of Athenian and Hellenistic imperialism and the ritual of *basanic* interrogation. But Warburg's insights into *mnemosyne*, and the manner in which motifs may be stored in memory and the body, provide the basis for a theory that accounts for the persistence of the pathos formula for more than two millennia. Like myths, the pathos formula discernible in the art of the Hellenic world and after has no single form and meaning for all time; it is thus not an archetype, but rather a recurring structure of thought and form that was used by successive individuals and regimes to rationalize, or simply think through, a particular imperial, exploitative or *basanic* practice. The pathos formula is, as Claude Lévi-Strauss said of myth, 'a language' made up of numerous variants, that together form 'a permutation group' which, when examined, permit us access to a fundamental component of the Western, Classical canon.[22] That formula and that canon, with its many variants, have performed diverse ideological functions.

In Rome, the pathos formula clearly served the needs of a vast empire based on a slave mode of production. The ruling classes of Republican and Imperial Rome were aristocrats who possessed great agricultural *latifundia* and sought to increase their wealth by the conquest of large tracts of distant lands. These

remote outposts of empire – in the Middle East, North Africa, and Europe (extending all the way to modern Scotland) – were governed by local aristocracies who pledged allegiance to Rome, and remitted to it taxes, goods and slaves. This latter importation permitted landowners in the Italian peninsula to achieve both increased agricultural productivity and greater control over their local peasant class, sometimes displacing them with imported slaves. Imperial authority, however, in Italy and abroad, was not only exercised by military means; it was also culturally enforced. The dissemination of the Latin language and Roman customs, political structures, kinship systems, property relations, law, art and architecture – in short, an entire cultural infrastructure – functioned to cement ties between the imperial centre and the colonial periphery.

The *Gemma Augustea*, a cameo cut from Arabian onyx by Dioscurides (or one of his followers), is a small but virtuosic token of that imperial culture (illus. 27). It depicts on the upper tier the crowning of Caesar Augustus amid the combined glories

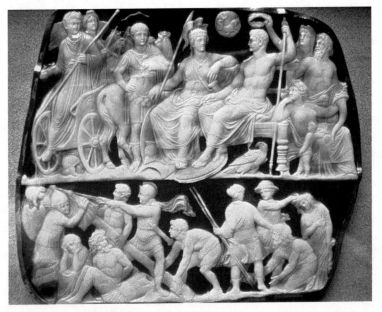

27 (?)Dioscurides, *The Gemma Augustea, c.* 20–10 BCE, onyx cameo.

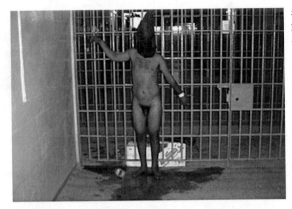

28 Standing prisoner tied up, Abu Ghraib, 2003.

of metropolitan Rome (home of the ruling dynastic families) and Olympos (home of the gods). Augustus, honoured here by Neptune and Jupiter among others, holds in his right hand the *lituus*, or augury stick indicating success in future military triumphs; below his feet are a pile of shields and armour, probably belonging to the defeated barbarian armies. In the lower registry of the stone is depicted the aftermath of a military victory, a precondition for the prosperity and glory represented above. Two bound and despairing figures are shown seated on the ground at lower left. Soon they will be tortured – bound to a *tropaion* (a wooden trophy shaped like a crucifix, adorned with armour) and together hoisted to celebrate the completion of a successful military campaign. Two more figures at lower right,

29 Unknown prisoners, Abu Ghraib, 2003.

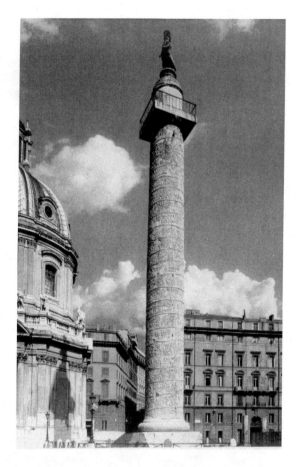

30 Column of
Trajan, *c.* CE 100,
Forum, Rome.

a man on his knees in a typical posture of surrender and a stand-
ing woman being dragged by her hair, must accept the dominance
of their captors, the gods Diana and Mercury. These barbarians
too may soon be tied to the *tropaion*, or if they are lucky, par-
doned and enslaved. In either case they are shown – like the
counterparts on the lower left – as wholly abject, dependent for
their very lives on the combined figures of gods and aristocrats.
Here brute force and complete surrender, not the subtleties of
an introverted domination (as at Pergamon), are predominant.
Such images of abjection are frequent among the Abu Ghraib
photographs.

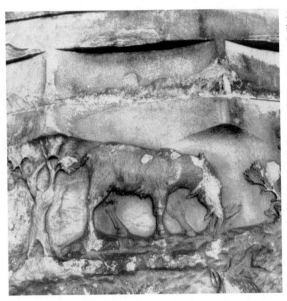

The famous Column of Trajan in the Roman Forum, erected *c.* 100 CE when the power of the Empire was at its greatest, depicts the Emperor's military campaigns against the Dacians in the form of an uninterrupted, 200-metre spiral relief coiling up the outside of a hollow, 40-metre tower (illus. 30). On the base supporting the column are reliefs of the spoils of war; above these, images of troops departing their secure forts (supervised by the Emperor himself), boats laden with supplies, legionnaires constructing a fort and many battle scenes. At the top of the columns are scenes of the destruction of the Dacian settlements (located in what is now Romania), the displacement of the native population, the surrender, parading and presentation of captives, the colonization of conquered lands (by military veterans) and finally, a poignant scene of a single, Dacian goat leading a long line of other animals and people into exile (illus. 31). Here the domination, destruction, enslavement or exile of a native people – even of its children – is represented as both moral and necessary. The apparent pathos of scenes of captured children on the columns of Trajan and Marcus Aurelius (the latter also in Rome, late second century CE), or of

women willingly surrendering their children to their conquerors, as on some second-century sarcophagi, were not intended to arouse pity for the victims of war, but admiration for the victors.[23] Indeed, the growing shortage of slaves, which would soon threaten the very existence of the empire, must have made such scenes especially gratifying.[24]

4
Pathos Formula

The lineage of artistic monuments that re-animated the antique pathos formula of entente between torturer and victim is long and, in a literal sense, distinguished, constituting the principal foundations of what Renaissance and later Italian theorists called *istoria*, and what British and German writers and academicians of the mid- and later eighteenth century called the 'Grand Manner' or the 'Grand Style', that is, an artistic language of metaphor and elevation derived from Greco-Roman antiquity and mythology, the Bible, and aristocratic history.[1] Thus the discipline of art history itself, insofar as its eighteenth-century foundations are inseparable from study of antiquity and the Renaissance, is also imbued with the ethos of the classical pathos formula. 'The style of Michelangelo', wrote Sir Joshua Reynolds in the last of his *Discourses Delivered to Students of the Royal Academy*, 'may be called the language of the Gods'.[2]

Michelangelo had seen the Laokoon group when it was first unearthed in Rome in 1506, and drew on it for his depiction of the *Execution of Haman* on one of the corner pendentives of the ceiling of the Sistine Chapel in Rome (illus. 32).[3] Here, and in the extraordinary, red-chalk preparatory drawings (illus. 33) in the British Museum and Teyler Museum, Haman (who plotted against the Jews, Mordecai, King Asahuerus and Queen Esther) is represented in the pose of the dying priest, Laokoon. His feet and hands have been nailed to a tree, but the finely articulated musculature of the body and dynamism of the posture – accentuated by the extreme calm of the seated and standing figures to the right

32 Michelangelo, *The Execution of Haman*, 1511–12, fresco, Sistine Chapel ceiling, Vatican Palace, Rome.

– signals ecstasy as much as torment. Unlike the ageing and abject figure described in the Book of Esther, this Haman is descended from a race of Gods; his extended arms – nearly perpendicular to the picture plane – and raised leg suggest a rapturous dance. Here, the purpose of the pathos formula is typological. Michelangelo represented Haman as an antitype of Christ; just as the death of the one was the salvation of the Jews, so the torment and crucifixion of the other was the salvation of humanity, and in each case excruciating pain and destruction may be represented as beautiful, and even erotic.

Michelangelo's *The Dying Slave*, derived from prototypal images of the martyrdom of St Sebastian by Perugino and others, manifests the pathos formula in the highest degree, eliding in a single marble body imperial conquest, physical constraint, ravishment and death (illus. 34). The marble captives of Michelangelo, intended either for the Julius Tomb or the facade of San Lorenzo in Florence,[4] were meant, according to Vasari,

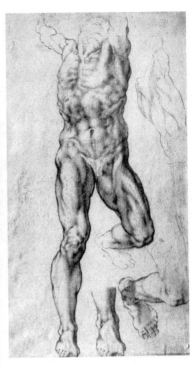

33 Michelangelo, *The Execution of Haman*,
c. 1511–12, red chalk drawing.

34 Michelangelo, *The Dying Slave*,
c. 1513, marble.

to signify the provinces subjected by Pope Julius, and brought by him into the obedience of the apostolic church. There were other statues, also bound, and these represented the Fine Arts and Liberal Sciences, which were thus intimated to be subject to death no less than that pontiff, by whom they had been honorably protected.[5]

Julius in fact, who compared himself to the Roman Emperor Julius for the breadth of his *imperium*, announced to the Fifth Lateran Council (1512) his plans for a new anti-Turkish crusade to retake the holy city of Jerusalem, a scheme embraced with zeal by numerous Renaissance orators and by the pope's successor, Leo X.[6] Thus for Michelangelo, according to Vasari, the idealism or *genio* of art, and the violence of conquest could be represented in the self-same sculptural figure. A principal source for this union was undoubtedly the Laokoon and Hellenistic art. Michelangelo had also likely seen the Roman copy of the Pergamene *Dying Celtic Trumpeter*, having adapted its composition for one of the figures in his lost fresco of the *Battle of Cascina*.[7]

Just three years later Michelangelo adapted the posture of his slave for drawings of *Christ at the Column* and *The Flagellation of Christ*, the latter now known from a copy by Giulio Clovio (illus. 35). The drawings were supplied by Michelangelo to his friend, the Venetian painter Sebastiano del Piombo, for a mural in oil in a chapel of San Pietro in Montorio, commissioned by the Roman banker Pierfrancesco Borgherini. In each of these drawings the bound and tortured figure of Christ is at once poised and writhing; he is derived both from the Apollo Belvedere and the Laokoon. That Christ at the moment of his crucifixion is often depicted as intensely beautiful, even sexually aroused, as Steinberg famously showed, indicates the degree to which the pathos formula permeated the very core of Western, Christian, cultic life.[8]

In later years, as Michelangelo's faith – in concert with wider Counter-Reformatory trends – turned more private and introspective, his art grew still more pietistic and ecstatic. In depicting his own features in the flayed skin of St Bartholomew near the centre of the altar wall of the Sistine Chapel (1536–41),

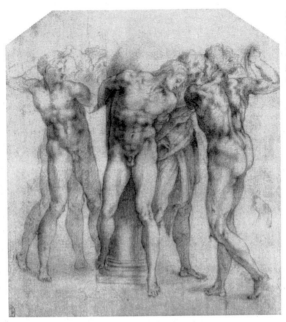

35 Giulio Clovio,
*The Flagellation
of Christ*, after
Michelangelo,
c. 1545, red chalk
drawing.

he was precisely expressing his belief that the revelation of truth required purgation, and that salvation demanded chastisement. Such lessons as these were not just shouted from the pulpits of Florence and Rome; they were also seen, as Samuel Edgerton has shown, on the streets of the two cities. It was the task of the Arch-confraternity of San Giovanni Decollato, of which Michelangelo was a titular member, to accompany condemned criminals to the gallows or other place of execution, and hold before their eyes painted images (*tavolette*) of the Scourging of Christ, the Crucifixion, and the torture or dismemberment of various saints, the subject generally selected to match the intended method of execution. (Edgerton argues that death by hanging – the most common form of execution – called for *tavolette* depicting the Deposition or Lamentation on the basis of the ladders essential to each.[9]) Michelangelo's own, enormous altar wall representing the Last Judgment therefore, as well as his sculptures of slaves or captives, may be seen in one respect as oversized, highly expressive, and supremely ambitious *tavolette*; they mediate

36 Sodoma,
St Sebastian, 1531,
oil on canvas.

between civic and canon law, and between physical chastisement and spiritual salvation.

Michelangelo's *The Dying Slave* was reprised by Sodoma in his *St Sebastian* (illus. 36), of which the late Victorian art historian and aesthete J. A. Symonds writes: 'Suffering, refined and spiritual, without contortion or spasm, [he] could not be presented with more pathos in a form of more surpassing loveliness . . . Part of its un-analysable charm may be due to the bold thought of combining the beauty of a Greek Hylas with the Christian sentiment of martyrdom. Only the Renaissance could have produced a hybrid so successful, because so deeply felt.'[10] Here the pathos formula assumes a homoerotic cast that would reappear much later –

cruder, and inflected with racism and imperial triumphalism – in the pictures from Abu Ghraib.

The image of the infidel who willingly embraces his own chastisement and captivity is visible in Raphael's *Battle of Ostia* (illus. 37). Here the artist depicts the defeat of the Saracens (Muslims) at Ostia in 849, and their surrender to Pope Leo IV, namesake of Raphael's patron and possessor of a 'plenitude of power . . . limited by no human law'. Bound and kneeling captives, recalling those represented on the Column of Trajan and the *Gemma Augustea*, are shown at lower left in postures of ostentatious self-abasement. The Pope meanwhile gazes heavenward to receive sanction from God, depicted in the adjacent ceiling by Perugino. The fresco thus enshrines the military and moral superiority of European Christians over Muslims from the East, provides benediction for Pope Leo X's planned new crusade against the Turks, and articulates a unity of oppressive purpose from one generation (Perugino) to the next (Raphael). The origin of the modern Western antagonism toward Islam is thus illustrated here in the Vatican, in a fresco commemorating 700 years of crusades, and in the image of a conquered and abject race.

37 Raphael, *Battle of Ostia*, 1514–17, fresco, Stanze dell'Incendio, Vatican Palace, Rome.

38 Giorgio Vasari, *The Battle of Lepanto*, 1573, fresco, Sala Regia, Vatican Palace, Rome.

A bit more than half a century later, an even more naked celebration of violence and torture was depicted on the walls of the Sala Regia, a large Papal audience chamber constructed in the 1530s and 1540s. The room, wedged between the Sistine Chapel, the Stanze and the Scala Regia, is a veritable chamber of horrors. The frescos – by Taddeo Zuccaro, Giorgio Vasari and others – all depict the triumph of Catholicism over heresy, and the doctrine of papal absolutism. They are as remarkable for their functional reportage – an aestheticizing of politics centuries before Benjamin coined the phrase – as for their violence. Two scenes by Vasari represent the Battle of Lepanto, the recently concluded naval victory of the Holy League of Rome, Habsburg Spain and Venice over the Turks, or Muslims (illus. 38). The second of the two scenes shows Faith, in a posture that recalls the Athena in the Pergamon Altar, crushing a number of bound and writhing Turkish captives, while at the upper right another group of Eastern monsters and heathens are routed by saints and angels stationed at upper left. Here

the demonization of Islam, undertaken by Raphael sixty years before in his nearby Stanze, is brought to a new extremity.

In the frescos *The Massacre of the Huguenots* and *The French King Defending the Murder of Coligny in the Parliament* (1572–73) Vasari portrays the state sanctioned, month-long slaughter of 30,000 Protestants as a single act of divinely inspired retribution against an army of grotesque and leering blasphemers. The brutal events had taken place in August 1572; three months later, Pope Pius IV commissioned the frescos, and by March 1573 Vasari had completed his work.[11] His scene of the Catholic king's defence of the massacre is a representation of the deployment of classical rhetoric in defense of the unspeakable, a kind of Nuremberg trial in reverse.

The frescos in the Sala Regia lack the balance and compositional clarity evident in works by Italian artists from earlier in the century. The judicious synthesis of opposites, the subtle combination of real and ideal, the rational justification for brutality (even if ultimately unsatisfactory) is lacking in these shrill exclamations of the justice of military coercion and genocide. The guiding philosophy here may be found in St Augustine (354–430) who claimed that 'the first cause of slavery is sin' and that slaves can make their slavery, in a sense, free, by serving not with the slyness of fear, but with the fidelity of affection, until all injustice disappears and all human lordship and power is annihilated, and God is all in all.[12] For Augustine, might makes right and the slave attains freedom by loving his master. The style of these artworks – generally dubbed 'Mannerist' – manifests a flamboyance and virtuosity that is the artistic equivalent of what in rhetoric is called the apodictical: the striking aesthetic form is its own justification, the florid argument is its own proof. This approach to the marriage of art and power was inaugurated by Raphael and Michelangelo, but reached its contradictory pinnacle in the decades following the latter's death.[13]

Titian's *Philip II Offering the Infante Don Fernando to Victory*, with its beautifully poised, bound Turk in the foreground – again recalling the Trajan Column and the *Gemma Augustea* – is another monument that embraces Classical, and subsequent Pauline and

39 Titian, *Philip II Offering the Infante Don Fernando to Victory*, or, *Allegory of the Battle of Lepanto*, c. 1572, oil on canvas.

Augustinian precepts concerning divinely sanctioned torture and enslavement (illus. 39). The engraved illustrations by the Flemish artist Theodore de Bry for the *Brevissima relacion de la destruyción de las yndias* by the Spanish humanitarian priest Bartolomé de las Casas, such as his print of 'Punishments met out by the Spanish upon unruly slaves', were indictments of the *encomienda* system of New World plantations and instrumental in establishing the 'black legend' of brutal and superstitious Spain. But there is no reason to believe that his extravagant images of tortures and atrocities engendered sympathy for Indian victims so much as stimulated hatred of Catholic Spain.[14]

And the cult of sacred and eroticized violence gained still more adherents during the Baroque, a period of veritable Hellenistic revival, when it buttressed at once Counter-Reformatory doctrine and a highly exclusive and privatized humanism. The combined erotic and sanguinary desires of noble and religious patrons were

gratified, for example, by representations of martyred saints, such as the *Martyrdom of St Bartholomew* by Jusepe di Ribera (illus. 40). The saint, who has assumed the posture of Laokoon (turned on his side), is depicted the moment just after his torture has commenced; he looks heavenward with a combined expression of pain, resignation and beatitude. The painting is thus a horrific distillation of a pathos formula that had seen its origin more than two millennia before. Now the victim is shown welcoming his torment because it is in emulation of Christ's own suffering; pain is a testament of the sufferer's devotion to God. The torturer himself becomes a divine instrument in the miracle of salvation.

The artist who most fully institutionalized the Baroque pathos formula was Gianlorenzo Bernini. His work at St Peter's in Rome, begun in 1624 and spanning five decades, should be under-

40 Jusepe di Ribera, *Martyrdom of St Bartholomew*, c. 1644, oil on canvas.

stood as a single, monumental project of artistic 'propaganda'. (The term derives from the *congregatio de propaganda fide* – congregation for propagating the faith – established in 1622 by Pope Gregory xv.) Indeed, the scale of Bernini's work is daunting in every respect. The great colonnade of St Peter's Square – a triple corridor of more than 250 Doric columns – surrounds a vast, elliptical piazza in the middle of which is an ancient Egyptian obelisk, marking the centre of St Peter's Square as the centre of the world. The forest of columns is divided into 96 bays, above which are an equal number of martyrs or saints. The beckoning arms of the colonnades and the army of statues, lend a dynamic impetus to the mass of people who ritually cross the Bridge of Angels (also decorated with sculptures by Bernini), pass into the piazza, and enter the basilica through the portal and narthex. The pilgrims then gaze down the wide nave toward the crossing, above which is a huge bronze canopy or *baldacchino*, also designed by Bernini.

The crossing was also furnished with four giant statues of saints intended to underscore the veneration of the four principal relics of Christ's suffering or 'Passion', installed under the cupola in the four main piers. Pope Urban viii decided to hollow out these piers with chapels devoted to the veneration of the cherished relics, one of which was the lance of the Roman soldier Longinus, used to pierce the side of Christ, and from which the blood and water of the Eucharist were believed to have emanated. Bernini's statue of *Longinus* shows the saint expressing his devotion to the relics above, but his gaze seems equally to soar into the cupola and heaven beyond (illus. 41). The outstretched arms of Longinus are meant to conjure an ecstatic unity of feeling and faith. The figure is clearly derived from the Hellenistic Laokoon (illus. 23; notice the consonance of expressive heads and outstretched arms), in each case representing not self-realization but reification and introversion, that is, the subordination of self to authority, hierarchy and doctrine. Bernini's innovation – which became paradigmatic for much of Catholic Europe – was to supersede anatomical plausibility – still just sustained in the sculpture of Michelangelo – in order to highlight spirituality. Indeed, while the figure of

41 Gianlorenzo
Bernini, *St Longinus*,
1629–38, marble.

Longinus appears at first glance to be realistic, his overstretched
skeletal structure and exaggerated musculature destroy any equi-
librium of body and soul. The former thus becomes nothing more
than a cipher intended to convey the dogmatism of absolute
devotion. But within a century, a new artistic realism – founded on
trust in reason and the human senses – would begin to shake and
even dissolve the authority of revelation. The result would be the
first successful efforts to displace the pathos formula from the
thematic and ideological centre of the most ambitious works of
classically influenced painting and sculpture.

5
Stages of Cruelty

The weakening authority of the classical tradition in the eighteenth and nineteenth centuries, a function of assaults on state-supported artistic institutions in France and Britain, as well as the emergence of a new, modern art devoted to bourgeois and even working-class life and materiality, gradually undermined the prestige of the long established Hellenistic pathos formula. The representation of introverted oppression, eroticized chastisement or rationalized torture disappeared from painting and sculpture most quickly in those places in which absolutism – the idea that the monarch is above the law and unconstrained by human sanction – was weakest. In the middle of the eighteenth century, the English painter and graphic artist William Hogarth pilloried the tradition, which he called 'dark and lugubrious', with his satirical engraving *The Battle of the Pictures*, showing an onslaught of framed canvases of martyrs, saints and other victims against the artist's own, healthy and robust images of middle-class English life, what he called 'modern, moral subjects' (illus. 42). His treatise *The Analysis of Beauty* (1753) was intended to put paid to the ancient tradition and forestall the establishment of a Royal Academy in England, organized along Italian and French classicizing principles. (He failed in his effort, and the Royal Academy was instituted in 1768, headed by Joshua Reynolds.)

At about the same time as he was composing *The Analysis of Beauty*, Hogarth offered a succinct and compelling artistic assault on the antique pathos formula whereby victims are shown welcoming their own torture or death. Perhaps because of the novelty

73

42 William Hogarth, *The Battle of the Pictures*, 1744–45, engraving.

of his insight, he chose to couch it in terms of the relationship between humans and animals. A series of engravings entitled *The Four Stages of Cruelty* (1751) depicts the deplorable and rapid descent of one Tom Nero, a ward of London's St Giles parish, from petty ruffian to murderer. Instead of focusing however, as he had in earlier satiric prints, on the corrupting influences of greed, gambling, strong drink and debauchery, Hogarth examines the marriage of criminality and cruelty to animals. The general argument of the series is that the latter is a precondition of the former, but the illustrated catalogue of abuses in the first two plates is so great, that the spectator cannot but feel that the fate of the animals, not the humans, is the artist's chief concern. The dog in the 'First Stage of Cruelty' penetrated by an arrow, and the horse, lamb and donkey beaten in the 'Second Stage of Cruelty' are just some of the represented horrors (illus. 43 and 44).

43 William Hogarth, 'The First Stage of Cruelty' from *The Four Stages of Cruelty*, 1751, etching and engraving.

44 William Hogarth, 'The Second Stage of Cruelty' from *The Four Stages of Cruelty*, 1751, etching and engraving.

45 *Ashurbanipal in his Chariot Hunting Lions*, *c.* 645 BCE, relief from the North Palace at Nineveh.

Hogarth's perspective may be contrasted with that of classical and pre-classical representations of the hunt (the only genre of art in which is found dramatic interaction of animals and humans), for example the scenes of *Ashurbanipal in his Chariot Hunting Lions* from the North Palace at Nineveh, which depicts numerous dead and dying animals (illus. 45). The tragedy that attends each individual, stricken animal is extreme, but the collective effect is anaesthetizing. As Bersani and Dutoit write: 'Each lion is a perfect "esthetic" object; and the real subject of these violent scenes may even be thought of as the technique by which all violence has been denied.'[1] The same denial of overall affect is apparent in Paolo Uccello's *The Hunt in the Forest*, in which all the creatures (and there are nearly one hundred aristocratic men, grooms attendants, horses, dogs and stags) and the pathos of the hunt are subsumed by the dominating perspective and decorative order (illus. 47). A somewhat different treatment of the hunt is apparent in Peter Paul Rubens's *Wolf and Fox Hunt*, which portrays the hunt as a pitched military battle against proud, fierce and able foes, with armed forces at last surrounding the enemy on three sides (illus. 46). In fact, fox and especially wolf hunts in the Spanish Netherlands in the second decade of the seventeenth century were conducted by well-armed militias – led by a trained,

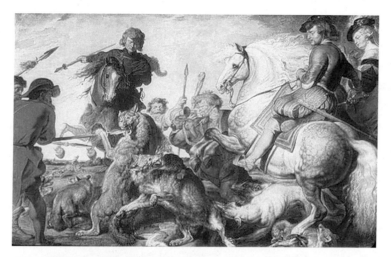

46 Peter Paul Rubens, *Wolf and Fox Hunt*, c. 1617–21, oil on canvas.

47 Paolo Uccello, *The Hunt in the Forest*, c. 1460, oil on panel.

noble, wolf-hunter – with the aim of extirpating predators and replenishing game species lost during the years of warfare with the Netherlands.[2]

Hogarth's first two plates of *The Four Stages of Cruelty* are thus purposeful mockeries of noble hunts such as at Nineveh, and portrayed by Uccello and Rubens. The wanton torture and destruction of domesticated animals – dogs, horses and sheep – in Hogarth's plates can find no endorsement in law or any cynegetic text, rendering any perpetrator a criminal. Indeed, the final two engravings in Hogarth's series, 'Cruelty in Perfection' and 'The Reward of Cruelty' show Tom's arrest after the murder of his

48 William Hogarth, 'The Reward of Cruelty' from *The Four Stages of Cruelty*, 1751, etching and engraving.

pregnant lover Ann Gill, and the post-execution dissection of his body (illus. 48). A dog in the foreground of the latter print chews on Tom's heart, exacting a measure of revenge for the criminal's previous tortures of its fellows.

'The cruel treatment of poor animals', Hogarth wrote, 'makes the streets of London more disagreeable to the human mind than any thing what ever'. Such sentiments were rare in the eighteenth century, at a time when the scale and intensity of animal breeding, butchering and marketing was increasing rapidly. Soon, the European transformation of animals from creatures with souls (Aristotle) into mere things to be bought, sold, raised and slaughtered would be nearly complete. Starting in the mid-nineteenth century, the lives and deaths of animals would pass mostly unobserved by the majority of the European population, and the new meatpacking industry would embrace a lesson that classical, and classically inspired art – such as that from Athens,

Pergamon, Renaissance Florence and Baroque Rome – had long imparted to its audience: represent your victims as if they were taking pleasure, or at least accepting the rationality of their own annihilation. Laughing cows and dancing pigs have ever since decorated signs outside butchers' shops and barbecue joints. Meat packages similarly depict the joy of carnage. Tuna on TV commercials gladly snap at fishing lines and poultry laughingly choose one or another fried chicken franchise. Hogarth, however, would have none of this attitude, not even that of 'heifers lowing at the sky'. His alter ego, in *Self-portrait with Pug* (illus. 49), was a creature whose poise and self-assurance matched or exceeded his own, and who was shown paired with 'The Line of Beauty', that serpentine expression of Hogarth's demotic aesthetics .

Hogarth was nowhere more trenchant in his criticism of the classical tradition and its 'dark and lugubrious' pathos formula

49 William Hogarth,
Self-portrait with Pug,
1749, oil on canvas.

than when he wrote that he'd rather have been the creator of *The Four Stages of Cruelty* than the Raphael *Cartoons*. The series of prints was especially unsparing in its portrayal of the rich and powerful. The final plate showing a company of surgeons cruelly and grossly dismembering Tom's hanged body has an audience of wealthy merchants and aristocrats looking on. The poor, it is suggested, like cows, pigs, geese and chickens, are treated as mere organic machines – muscles, bones, organs, offal – given over for the consumption or sport of the wealthy and powerful. The spectator too is implicated in the cannibalistic carnival (note the boiling cauldron with the soup bones at the left) since the scene has an essentially frontal, or planar orientation. Our view is like that of the chief surgeon in his throne-like chair. It is therefore not surprising that by the end of the artist's life, 'Hogarthianism' – an aesthetic that emphasized the beauty of the everyday and the commonly observed, but which did not shrink from representing ugliness and cruelty – should have been so utterly opposed by masters of the still-reigning classicism and academicism such as Joshua Reynolds and Benjamin West.

The penal reform movement and abolitionism in England and France at the end of the eighteenth century – the former associated with the Italian Beccaria and the Englishman John Howard, and the latter with Thomas Clarkson and the French abbé Gregoire – additionally undercut the authority of the classical tradition and its pathos formula, or else inverted its meanings. The very imagery that once upheld or reasserted the moral rectitude of the unchecked exercise of power – kneeling and recumbent men and women in chains – was now marshalled for the purpose of invoking sympathy and arousing popular opposition to slavery and oppression. In an ideological context in which the social category of 'subject' was replaced by that of 'citizen', art could not plausibly represent the collusion of oppressor and oppressed. The jasperware cameo designed in 1788 by one of Josiah Wedgwood's craftsmen, showing a kneeling slave and bearing the legend 'Am I not a Man and Brother', may have continued to instate belief in the subservience of black to white (illus. 50). But it was nevertheless highly effective abolitionist propaganda, 'equal', Benjamin Franklin

50 Josiah Wedgwood, 'Am I not a Man and Brother', illustration in Erasmus Darwin, *The Botanic Garden* (London, 1791).

wrote, 'to that of the best written Pamphlet'.[3] It was reproduced on the title pages of tracts and broadsides, and was even used to ornament snuffboxes and bracelets. It appeared as well in the first volume of Erasmus Darwin's scientific compendium in verse, *The Botanic Garden*, stimulating the following lines of ekphrasis:

Here oh BRITANNIA! Potent Queen of isles,
On whom fair Art, and meek Religion smiles,
Now Afric's coasts thy craftier sons invade,
And theft and murder take the garb of Trade!
– The SLAVE, in chains, on supplicating knee,
Spreads his wide arms, and lifts his eyes to Thee;
With hunger pale, with wounds and toil oppress'd
"ARE WE NOT BRETHREN?" sorrow choaks the rest;
– AIR! Bear to heaven upon thy azure flood
Their innocent cries! – Earth! Cover not thy blood!

Darwin's poetry and Wedgwood's cameo draw their authority precisely from general familiarity with the ancient pathos formula

81

of the bound slave or captive begging mercy from a proud and omnipotent master. Now, however, without the cover of faith, divine right, Augustinian principles or Greco-Roman Republicanism, slavery and oppression – 'in the garb of Trade' – are insupportable. Now the pathos formula can be invoked to summon support for the struggles to achieve French, Spanish, American and Irish liberty.

Jacques-Louis David's portraits from 1793–94 of the revolutionary martyrs Marat and Barra further illustrate the transformation of the Hellenistic pathos formula from a sign of subservience to autocratic power to a token of emancipation. *The Death of Marat* (illus. 51) depicts the moments following the assassination on 13 July 1793 of a radical pamphleteer and *sans-culottes* politician. Marat was stabbed by Charlotte Corday while sitting in his bathtub working on his papers. (He suffered from a painful skin disease that was apparently soothed by frequent medicinal baths.) The revolutionary Convention was so moved by this event that it immediately charged David – a member of the Committee of General Security in charge of the Terror – to memorialize Marat by organizing a grand, public funeral in which his painting would be displayed in a makeshift chapel above a sarcophagus. *The Death of Marat* was clearly intended to turn the murdered writer and popular leader into a martyr for the revolutionary cause. Marat is shown holding Corday's petition in his left hand, and a quill pen in his right. The long, limp arm and hand, beside the makeshift wooden writing table, recalls the lifeless arm and stone slab in Caravaggio's *The Entombment of Christ* (illus. 52), well-known to any French artist trained in the state-supported Ecole des Beaux-Arts . The large wound on the right side of Marat's chest, like that on the body of Christ in the *Entombment*, is clearly visible, with hardly any visible drops of blood. The commemorative inscription on the writing table – 'To Marat – David', presents the artist not merely as the one who realized the commission, but as the comrade and disciple of the murdered politician.

The Death of Marat replays the Hellenistic pathos formula of the beautiful death, but does so in the name of the *sans-culottes*. Its populism is marked by Marat's nakedness and evident

A MARAT.
DAVID

51 Jacques-Louis David, *The Death of Marat*, 1793, oil on canvas.

poverty; the latter was the condition of the great mass of the Paris population in the difficult summer of 1793, before the stabilization of prices in November and December. In addition, references to the demotic art of Caravaggio – an artist noted for his elevation of workers and peasant into saints and martyrs – must be seen as a pointed rejection of the more conventional and hierarchic classicism of the pre-Revolutionary generation of

52 Caravaggio,
*The Entombment
of Christ*, 1603–4,
oil on canvas.

French artists supported by the official Academie des Beaux-Arts and Bourbon monarchy. Finally, the conveyance of the canvas in a popular festival exposes its functional difference from the grand, ennobling and elite tradition of history painting intended for churches and palaces; this was painting made for the streets, not for the court.

In his *Portrait of Barra* (illus. 53), David combined nudity, eroticism and death to signal the virtues of patriotism, courage and individual autonomy. Joseph Barra, a young man from the Vendée who in early 1793 was killed by Royalists for refusing to surrender some horses, became the subject of David's unfinished

53 Jacques-Louis David, *Portrait of Barra*, 1794, oil on canvas.

picture after his story (considerably embellished), was turned into an allegory of popular resistance to tyranny. The young man, his body twisted at the middle, in the approximate position of the Hellenistic *Sleeping Hermaphrodite* (illus. 54), clutches to his chest a tricolour cockade, symbol of the Republic. His rapturous expression, ambiguous gender and flawless body were taken to be signs of a virtue unstained by selfishness and any parochial needs or desires.

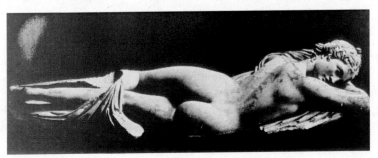

54 *Sleeping Hermaphrodite*, Roman copy of Hellenistic original, *c.* 150 BC.

Of course, it was Goya, as we have seen, who more than any other artist of the age challenged the classical tradition of the redeemed death in battle – the pathos formula that depicts oppressor and victim engaged in a transcendent entente. In his series of etchings *The Disasters of War* he depicted without glory the Spanish war against French invaders. French troops and Spanish *guerrillas* appear locked in desperate hand-to-hand combat, with no distinction between winners and losers, right or wrong, or often even dead and alive. Faceless killers execute nameless victims, as in 'One Cannot Look' (illus. 55). This is a war without triumph or respite, a cruel, issueless struggle that offers no hope for final redemption. And the etchings themselves were, in a sense, issueless. While Goya had confidently published his *Caprichos* in 1799 (only to withdraw them from circulation a few days later) and subsequently compiled his *Inquisition Album* as statements of enlightened faith in reason and reform, he had no hope of living to see *The Disasters* in print, and little surviving faith in reason. The copperplates on which he had worked so hard were left in his cabinets after his death in 1828 and were sold to the Royal Academy of San Fernando, which took until 1863 to publish a mere selection.

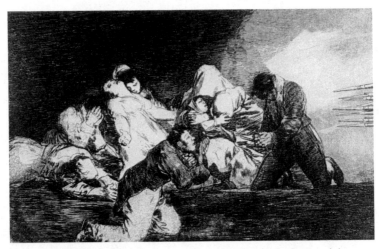

55 Francisco Goya, *One Cannot Look* ('No se pueda mirar'), from *Los Desastres de la Guerra, c.* 1814–18, etching.

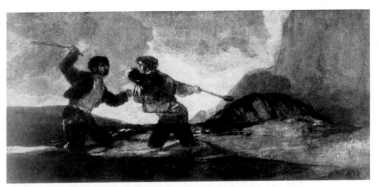

56 Francisco Goya, *A Fight with Clubs*, c. 1820, oil transferred to canvas.

In the last few years before he emigrated to France in 1823, Goya withdrew from the public to paint a set of murals in his own house, popularly known as *The House of the Deaf Man*. These so-called 'Black Paintings' (named for their dark colour and mood) were seen only by Goya, his family, and the friends he cared to admit. They are a series of enigmatic, fantastic, dream-like murals, covering all the walls between the windows and the doors. One of these, now called *A Fight with Clubs*, shows a struggle between two simple people, perhaps peasants, their feet buried in the ground (illus. 56). They are unable either to attack or retreat, so they will continue to fight – pointlessly – until they are each killed. This is a nightmarish visualization of the Spanish civil wars, and a revelation of the myth of redemptive war. The mural recalls one particular etching in the *Disasters* series, 'With reason or without', a more realistic variant of the same composition (illus. 57). Guerrillas and French soldiers, already wounded, fight on in close quarters, the guerillas with knives and a wooden pike, the French with their rifles and bayonets. The title of the etching summarizes the necessity of an individual stance of indifference to pain and misery when the larger struggle cannot be justified.

By the mid-nineteenth century, the visual language of Realism, exemplified in works by the French caricaturist Honoré Daumier and painters Gustave Courbet and Edouard Manet, also struck a blow against the ancient pathos formula. Now the art and rhetoric of the classical past could not be seen without irony or even

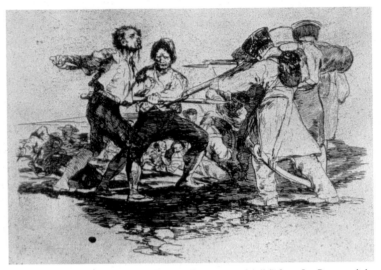

57 Francisco Goya, *With Reason or Without* ('Con razon o sin ella') from *Los Desastres de la Guerra*, c. 1814–18, etching.

open mockery; heroism no longer resided with Zeus, Athena and the other gods on Olympos, but with the *bon bourgeois* in his black frock coat on the boulevards of Paris or on the avenues of other European metropolises.[4] Religious faith could no longer be represented, as it had been during the Renaissance and Baroque periods, with images that upheld dogma, Church hierarchy and the transcendental nature of suffering, but rather, with pictures that revealed the crude and degrading factuality of the punishment and pain described in the accounts of saints' lives or the New Testament, as in Manet's *The Mocking of Christ* (illus. 58). Here, Christ is a pasty-skinned, knob-by-kneed Frenchman with a well-trimmed beard; his torturers are a motley group of oddly dressed workers of varied age and pallor, with calloused and bunioned feet, sunburned arms and necks, and uncertain expressions. Torture is shown here to degrade both tor-turer and victim and to hold no promise of revelation. By the late nineteenth century, the pathos formula in any form – oppressive or redemptive – was only rarely visible in the artistic media and venues for which it had been devised: painting and sculpture exhibited in churches, palaces, salons, academies and museums.

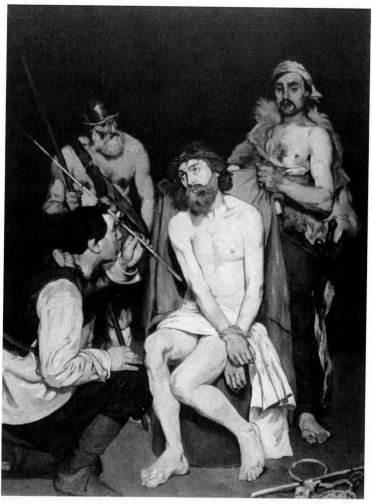

58 Edouard Manet, *The Mocking of Christ*, 1865, oil on canvas.

But the rise of imperialism at the end of the nineteenth century, and the appearance of authoritarian, mass-based regimes in Germany, Italy and the Soviet Union in the early twentieth – combined with the growth of an industrial, or monopoly capitalist 'culture industry' – fanned new flames from dying embers. Hellenistic classicism was ostentatiously revived

by both totalitarian and democratic states for public art purposes in the 1920s and '30s, most notably at the 1937 International Exposition in Paris (illus. 59), where the temporary pavilion of Nazi Germany, designed by Albert Speer, and the permanent halls of France, the Palais de Chaillot and the Palais de Tokyo, each exposed a grandiose, but ascetic architectural vision. Even more telling was the visual confrontation between the monumental sculptures atop the pavilions belonging to the Soviet Union and Germany. At the first, Vera Mukhina exhibited her colossal iron figures of *The Worker and the Collective Farm Woman*. The group, whose dynamism and militancy recalls both the Hellenistic Nike of Samothrace and the French sculptor François Rude's *Marseillaise* (1833–36), was set atop a stepped pavilion designed by Boris Iofan, and seemed, despite its obvious size and weight, about to take flight. At the second, a huge eagle was seen, symbol of both the German state and the Nazi party, while at its base was a bronze figure group by Josef Thorak called *Comradeship*. It signalled the bonds of blood and soil and the dreams of a thousand-year *Reich*. Though neither Nazi nor Soviet works were direct examples of the pathos formula, each were reiterations of an essential aspect of its underlying conception: the complete subordination of the body to doctrine, and

59 The International Exposition in Paris, 1937. To the left, beyond the bridge, stands the German Pavilion; facing it, to the right, is the Soviet Pavilion.

the willing surrender of the autonomous, critical subject to the dictates of state authority and power.

In the meantime, at the nearby Spanish Pavilion, Picasso exhibited *Guernica* (see illus. 6). This mural-size oil painting, intended to expose and protest the bombing of the defenceless Basque town of Guernica, is an ostentatious repudiation of the claim that Hellenistic classicism represents a timeless vision of beauty, rationality and order. Its contents are accusatory – no redeeming grace is visible, only the suffering of the victims and the outcry of the helpless. The sculpted warrior in this picture, survivor of an ancient martial order, is now dead and in fragments. Three women are seen wailing or screaming in protest at the destruction and death around them. The horse at the top of the picture does not go gladly to his slaughter, as do the cattle led to sacrifice on the Pan-Athenaic frieze from the Parthenon, or willingly engage in blood-sport, like the foxes and wolves of Rubens, but instead scream in protest, terror and pain. The figure at the top shown extending an oil lamp into the scene exposes the historical truth of crime and oppression. No enemy, authority, god, king, pope or judge is visible to make a claim for the justice of the destruction and death – there are only victims. *Guernica* is a work of art whose creator has suspended the oppressive, classical equation of beauty, order and power.

6
Muscle and Bone

But even so Promethean an artistic figure as Picasso could not extirpate the pathos formula, its oppressive power restored by fascist and imperial war, and its shadowed visage become almost ubiquitous. Since the end of World War II, it has been mass culture in its immense variety – consumed by ruling and subordinate classes alike, but controlled by state and corporate entities – that has most of all projected and monumentalized the willing subordination of the weak to the strong, and sanctioned the enactment of torture for the expression of power and domination. The formula may be seen in cinema and television, especially in western, crime, war, kung fu, slasher, espionage, police procedural and other genres. Specific examples of the eroticized torture of male and female protagonists are myriad, from James Bond movies to the TV show *24*. The mixture of torture and sex is frequently found in the novels of Ian Fleming and the subsequent film franchise. In the early 'telefilm' of *Casino Royale* (1953), Fleming's first Bond novel, broadcast on CBS television in 1954 as part of its 'Climax Mystery Theatre', 007 (played by Barry Nelson) matches his wits against a Soviet agent named Nelson Le Chiffre (played by Peter Lorre). After beating Le Chiffre at baccarat, Bond is followed back to his hotel room where he is again confronted by his antagonist (illus. 60). In the novel, Bond is bound to a chair and repeatedly struck on his genitals with a three-foot carpet beater, the unbearable pain gradually giving way to pleasure. Fleming writes that Bond experienced 'a wonderful period of warmth and languor leading into a sort of sexual twilight where pain turned to

60 Shots from *Casino Royale*, Ian Fleming's first Bond novel, broadcast on CBS television as part of its 'Climax Mystery Theatre' in 1954.

pleasure and where hatred and fear of the torturers turned to a masochistic infatuation'.[1] In the television adaptation Bond is tied to a bathtub and his toenails are pulled out – the Freudian substitution must have come easily to the scriptwriter Charles Bennett, who usually wrote for Hitchcock – but the eroticization remained. The close-up reaction shots of Bond and his girlfriend Valerie Mathis (played by Linda Christian) emphasize their intimacy, and that between torturer and victim.

Bond's genitals are in fact regularly threatened and fetishized by his enemies, as in the novel *Never Say Never Again*, when Fatima Blush – with whom 007 has already had sex – picks up her gun, orders Bond to spread his legs and says: 'Guess where you'll get the first one?'[2] And of course there is the famous scene in the film of *Goldfinger* in which Bond is tied, spread-eagled, to a table and threatened first with castration and then with death by an industrial laser (illus. 61). Bond asks Goldfinger, with stoicism: 'Do you expect me to talk?', to which his nemesis casually replies: 'No,

93

Mr Bond, I expect you to die!' In the Bond novels and movies, as in the hard-boiled thrillers of Mickey Spillane, 'love', as Umberto Eco has written, is transformed into 'hatred and tenderness to ferocity'.[3]

In the recent and popular television series *24*, which concerns itself with the heroic and mostly illegal efforts of one Jack Bauer (played by Kiefer Sutherland) and his 'CTU' (Counter-Terrorism Unit) to identify and stop terrorist plots, torture is ubiquitous and completely normalized. It even occurs between members of the same family, as in an episode in the fourth season when the Defense Secretary orders the torture of his own son who has been implicated (falsely it turns out) in his father's kidnapping. 'In casting torture as melodrama', the critic Richard Kim writes,

> *24* reverses the dehumanizing mode of actual torture and replaces it with something familial and social. So blasé are these victims of torture that they come as close as one can to consenting to it. In this instance, popular culture construes

61 A still from Guy Hamilton's 1964 film of Ian Fleming's *Goldfinger*.

torture as a humanizing social ritual enmeshed not in war and violence but in the drama of family and love life.[4]

(The programme, which popular radio personality Rush Limbaugh called 'a pro-America show', was a favourite of Homeland Security Chief Michael Chertoff and other high-ranking members of the Bush administration.[5])

The antique pathos formula which treats torture as a necessity for obtaining truth and ordering society is also widespread in less regulated mass-media formats: in illustrated racist and white supremacist books and pamphlets, in tabloid photo-journalism, in snapshots from hunting trips (trophy shots), in violent or racist postcards and in comic books. The quantity and variety of this material is enormous – dating from the beginning of the twentieth century to the present – and parallels with the Abu Ghraib pictures – to which we may now return – are easy to draw.

A postcard (illus. 62) showing African Americans 'scrambling for money' before amused, Southern, white, male onlookers (they stand beside bales of cotton), anticipates the image from Abu Ghraib of a pile-up of Iraqis and the broad grins of two US soldiers, Charles Graner and Sabrina Harman (see illus. 20). Both pictures were intended to be funny. In the first instance, the putative humour derives from the contrast between the patronizing calm of the white men with straw hats who face us, and the frenzy of the black men, seen mostly from behind, who dive for coins. In the second, the humorous intention is similar; the white people look out at us with knowing grins, while the prisoners with hoods form an ugly and indecorous mass. 'Look what these people will do!', both pictures say: 'At any invitation to profit or pleasure, dark-skinned people will cast self-respect to the devil!' Though we know in each case that it was the white people who forced the black men and prisoners to form the piles, their grins are intended to persuade us that it was all in good fun.

The picture from Abu Ghraib, and the many others like it, document a form of torture – naked, hooded men forced into a pile, their humanity degraded and their lives threatened by suffocation – that in the minds of the prison guards is indistinguish-

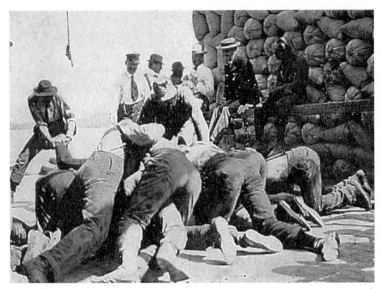

62 'Negroes scrambling for money', *c.* 1925, postcard.

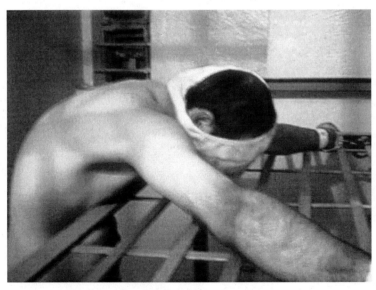

63 Unknown prisoner tied to a bed-frame, Abu Ghraib, 2003.

able from a joke. The humour is frankly racist, and we can guess how the white instigators of this joke would respond to stares of horror or incomprehension: 'What, don't you get it? Where's your sense of humour?' In colonial or settler contexts – whether domestic or exotic – nearly all humour is racist. In Iraq as in the us, such humour is a means of aggression that is permitted where others are ostensibly denied. Here the pathos formula – the representation of collusion between torturer and victim – takes the form of a joke whose victim is always the non-white.[6]

Additional imagery comparable to the Abu Ghraib photographs can be found at white supremacist and other racist websites, where black, Jewish and Arab (or Muslim) men are impugned at once as hypersexual and effeminate, and where homosexuality and transvestism are particularly stigmatized.[7] The photographs from Abu Ghraib of prisoners tied to bed-frames and masked with women's underwear combines these far-right fantasies and hatreds (illus. 63, 64). The picture below was one of many taken on 18 and 19 October 2003, either of a detainee named in Criminal Investigation Command (cid) files as 'h', or else 'w', also known as 'the taxi driver'.[8] Charles Graner told investigators that he had been ordered by superiors to strip, hood and shackle the man, and then subject him to stress position and

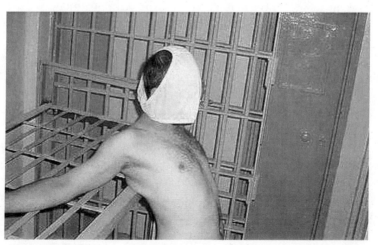

64 Tied to a bed-frame at Abu Ghraib, 2003.

sleep deprivation. The prisoner H himself later recounted: 'He [Graner] cuffed my hands with irons behind my back to the metal of the window, to the point my feet were off the ground and I was hanging there for about 5 hours just because I asked about the time, because I wanted to pray. And then they took all my clothes and he took the female underwear and he put it over my head. After he released me from the window, he tied me to my bed until before dawn.'

The purpose of forcing inmates to wear women's underwear, according to the report of General George P. Fay, was what Military Intelligence called 'ego down', a form of sexual humiliation – especially aimed at Muslim men – intended to help establish 'favourable conditions' for interrogation. Other forms of sexual abuse in the prison were clearly intended to gratify the hatreds and homophobia of the guards, and at the same time allow them to believe that the victim might actually enjoy the violation. A civilian translator named Nakhla, employed by the Titan Corp., translated the following typical litany of verbal abuse: 'Don't try to run away. Stop right there. Are you gay? Do you like what is happening to you? Are you all gays? You must like that position.' This idea, that the prisoners actually welcomed sexual humiliation and violation was expressed as well by various American, right-wing commentators about Abu Ghraib, including Rush Limbaugh, who was quoted as saying on his radio show, aired on 3 and 4 May 2004: 'This is no different than what happens at a Skull and Bones initiation: I'm talking about people having a good time!', and 'We have these pictures of homoeroticism that look like standard good-old American pornography.'[9]

The point of these tortures at Abu Ghraib and the stereotypal pictures – fully sanctioned by explicit rules of engagement and the chain of command[10] – was not to obtain information from enemy combatants, or even to inflict punishment; it was to shame prisoners and to gratify by means of a touchstone or test – *basanos* – the feelings of national and racial superiority of the soldiers and civilians at Abu Ghraib and elsewhere, and to uphold the moral and political necessity of the American military venture in the face of worldwide opposition and condemnation. And still more

broadly, it was to affirm the naturalness and inevitability of a political, economic and cultural system – constantly under threat by nations on the periphery or semi-periphery – whereby the United States occupies the core of a global order.

In bringing together racist postcards and the Abu Ghraib pictures, I am not suggesting that one is a source for the other. Indeed, historians of art and visual culture need to remember that not all images have a specific, pictorial source; some derive from memory and experience. Most of the time, kneeling is a posture that signifies capitulation, and nakedness is a sign of vulnerability. Similarly, to be bound is to be a prisoner, to exercise ones limbs without constraint is to be free; the one who watches is stronger than the one who is watched; to be confined to a small space is to be poor, while to have access to abundant light and room is to be rich; to gaze into the eyes or at the camera lens is to show confidence; to look away suggests deference or insecurity. These bodily expressions of power and subordination are so well internalized that new pictorial articulations, such as the Abu Ghraib photographs, can be produced at will, without dependence on particular visual prototypes. But it is precisely the long Western history of the representation of torture that has helped inscribe an oppressive ideology of master and slave on our bodies and brains, enabling (especially at times of fear) a moral forgetfulness or even paralysis to set in – an 'Abu Ghraib effect'. For to inscribe or represent, as the sociologist Paul Connerton reminds us – to sculpt, paint, take a photograph or even to write – is also to move and behave in the world.[11] The repetition of these acts of mimetic inscription by artists and writers – and vicariously by viewers and readers – incorporates into our bodies ancient habits and expressions of authority and subordination. Indeed, it is the special capacity of the *Pathosformel* of 'passionate suffering', according to Warburg, that it may 'persist as a heritage stored in the memory . . . determining the outcome shown by the artist's hand as soon as exaggerated values of expressive movement reach daylight via the artist's creativity'. This does not at all mean, of course, that artists and viewers are fated to repeat brutalities of the past by virtue of the fact that we often see them represented, but it does

argue that the guards at Abu Ghraib, just like the men who took photographs of, and made postcards from, the lynching of African Americans, did not need to know about the Pergamon Altar to have enacted its language, its pathos formula – they knew it in their eyes and hands, they felt it in their muscles and bones.

7

Theatre of Cruelty

But there is at least one feature of the Abu Ghraib prison photographs that puts them squarely into the art-historical and mass culture tradition – which includes lynching images – mentioned here: their emphasis on theatricality and display. The torture scenes in Baghdad were organized to be photographed. Prisoners are piled on top of one another like circus acrobats or players in a rugby scrimmage, naked men pantomime sex acts, a female soldier struts as a dominatrix, a dog menaces a prisoner who recoils in fear. In a few of the images, there appears to be a self-conscious striving for melodrama or pathos, as with the iconic photographs of hooded prisoners slumped and handcuffed to a railing, or standing on a box with arms extended. In many of them, the artifice of the scenes is signalled by the looks and hand gestures of the guards. The photographs thus stage and record two kinds of desire: first, the supposed, perverse desires of Islamic detainees; and second, the actual, un-repressed desires of the US prison guards who freely wield guns, fists, handcuffs, dogs and leashes. The presence of the one provides ideological justification for the other, the supposed bestiality of the victim justifies the crushing violence of the oppressor: 'The military and the new Right, like the conquerors of old, discover the evil they have imputed to these aliens, and mimic the savagery they have imputed.'[1]

Torturers strive to create an intimate theatre of cruelty. Not in Antonin Artaud's sense of an arena in which the performance of terror and frenzy releases the repressed desires of participants and onlookers, but in the sense of a closed and claustrophobic

If your answer is still "yes" ...

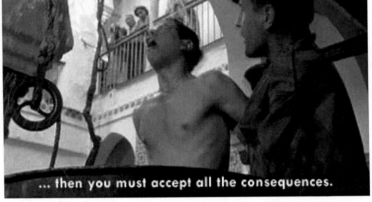

... then you must accept all the consequences.

65 Stills from Gillo Pontecorvo and Franco Solinas's 1966 film, *The Battle of Algiers*.

space where victims are made neurotic or even psychotic. They are controlled and rendered both abject and dependent. This kind of scenario is exposed at the beginning of Gillo Pontecorvo and Franco Solinas's film *The Battle of Algiers* (illus. 65), derived from events of the Algerian War of Independence and the prison memoir of Saadi Yacef, a key commander of the FLN (Algerian National Liberation Front). The opening scene, set in the French paratroopers' headquarters, depicts the aftermath of torture, and the pathetic reliance of the victim on his torturer:

A para, named Marc, rushes down the stairs, and asks cheerfully while running:

MARC: The colonel. Where's the colonel? . . .

His voice echoes through the corridors, on the landings, from one floor to another. The excitement is contagious. Many crowd around the door of the kitchen.

The Algerian who has 'spoken' is there. He is young with a thin face and feverish eyes. The paras are all around him: they help him stand up, dry him, clean his face with a rag, give him some coffee in a thermos cover. They are full of attention, sincerely concerned. One of them tries to push away the others.

PARA: C'mon, let him breathe!

Meanwhile others who are arriving ask if it is true.

OTHER PARAS: So he spoke? Does he really know where Ali is?

MARC: It seems so. We'll go see. Give him a little coffee . . .

PARA : Hey Marc, you made him talk?

MARC *(smiling)*: Sure.

He then begins to smoke again, and moves aside to rest a bit. The Algerian is trying to drink, but his hands are trembling. Someone helps him and holds still the cover of the thermos, drawing it to his mouth:

LAGLOY : C'mon Sadek . . . Drink, you'll feel better.

The Algerian drinks, but his stomach can't take it, causing him to double over and vomit again. Colonel Mathieu enters, elegant and graceful.

MATHIEU *(smiling)*: At ease. Is it true?

MARC: I think so. Rue des Abderames three . . .

MATHIEU: Dress him.

Then he goes near the Algerian, lifts his chin, inspects him for a moment with curiosity.

MATHIEU: Chin up, it's all over. Nothing can happen to you now, you'll see. Can you stand up?

The Algerian nods yes. The colonel turns to the paras who are holding him up.

He takes the camouflage fatigues and hands them to the Algerian.

MATHIEU: Here, put them on . . .

The Algerian shivers from the cold. He is completely naked. He laboriously puts on the fatigues, which are too big for him.

This scene is a repudiation of the oppressive, antique pathos formula.[2] A group of Frenchmen stand around, smoking, chatting, joking, while an Algerian is being tortured. It is a job for them. They take a measured pride in their work, and when they achieve a success – the tortured man talked – they are pleased. They call their boss, they extend congratulations all around, including to the torture victim, to whom they now offer comfort and encouragement; the same men who a few minutes before were burning him with cigarettes, subjecting him to electric shocks, or plunging his head into water until he nearly drowned – a technique called 'water-boarding'.

This last torture was specifically approved by President George W. Bush in 2002 for use against suspects in the global war in terror, according to reports in the *Wall Street Journal*, ABC News, *New York Times* and other sources.[3] The practice has a long history, dating back at least to the late Middle Ages, when it was favoured in witchcraft trials. In the early twentieth century British industrialists authorized its use, along with dozens of other tortures, against the Putumayo Indian labourers living on the upper Amazon in Peru when the harvest of rubber fell below assigned quotas. Roger Casement, British Consul-General to Rio de Janeiro, issued a report on the cruelties in 1912, for which he was later knighted. His report, as Taussig notes, evokes the casualness of the torturers, and the banality of the scenarios. 'The employees at all the stations passed the time when not hunting Indians, either lying in their hammocks or gambling.'[4] Their boredom was interrupted only by the frequent brutalities, such as

water-boarding, 'designed', Casement writes, 'to stop just short of taking life while inspiring the acute mental fear and inflicting much of the physical agony of death'.[5]

The French paratroopers in Algeria also used the technique, according to the testimony of the journalist Henri Alleg in *The Question*, the searing and widely read account of his internment and torture, published in 1957. An interrogator tied the naked Alleg to a plank, wrapped a rag around his head, and forced his mouth open with a wooden wedge. Then a rubber tube, attached to a spigot was suspended over his face. Alleg writes:

> When everything was ready, he said to me: 'When you want to talk, all you have to do is move your fingers.' And he turned on the tap. The rag was soaked rapidly. Water flowed everywhere: in my mouth, in my nose, all over my face. But for a while, I could still breath in small gulps of air. I tried, by contracting my throat, to take in as little water as possible and to resist suffocation by keeping air in my lungs for as long as I could. But I couldn't hold on for more than a few moments. I had the impression of drowning, and a terrible agony, that of death itself, took possession of me. In spite of myself, all the muscles of my body struggled uselessly to save me from suffocation. In spite of myself, the fingers of both hands shook uncontrollably. 'That's it! He's going to talk,' said a voice.[6]

(Under pressure from the UN the US State Department announced in May 2006 it would list water-boarding as a forbidden practice in its classified, US Army Field Manual. It is not clear if all other branches of the military and government – CIA, FBI, NSA and private, military contractors – would be bound by the same prohibition.)

The theatricalized torture revealed by the Abu Ghraib photographs was also anticipated by the US supported, anti-insurgency campaigns against leftists in Guatemala and El Salvador in the 1970s and '80s. The latter dirty war was emblematized by the massacre at El Mazote, El Salvador, in December 1981, perhaps the worst such atrocity in Latin American history. On that occasion, the Atlacatl brigade, its officers trained by US military

advisors, entered a village in northern Morazon province and proceeded over a two-day period to torture and kill over 900 unarmed *campesinos*.[7] Despite eyewitness accounts and unimpeachable forensic evidence, the US administration led by President Ronald Reagan denied that the massacre had taken place, slandered the reporters who exposed it, and continued military aid and training to the Salvadoran army. That support, as well as atrocities by the Atacatl brigade, continued for the rest of the decade.[8]

During these years the US painter Leon Golub, recalling the art of Goya, undertook a series of works designed to expose US complicity in torture, and examine its physical, psychological and theatrical aspects.[9] Golub's *Mercenary, Interrogation* and *White Squad* series from the late 1970s and '80s are life-size figure paintings of leering, hyper-masculine men of uncertain nationality or race, shown taunting or abusing seated, kneeling, bound, hooded or otherwise subordinate men or women. The paintings, including *Interrogation II* (illus. 66), were derived from news photographs and journalistic accounts of actual torture scenarios in South Africa, Guatemala, El Salvador and elsewhere. Scab-coloured, scraped raw, un-stretched, unframed and hung from

66 Leon Golub, *Interrogation II*, 1981, acrylic on linen.

grommets, the paintings themselves appear to have been beaten and abused, the physical evidence of prior acts of debasement and torture. Golub lived to see the photographs from Abu Ghraib, and told his friend, the critic David Levi Strauss that

> the techniques pictured – hooding, forced nakedness, sexual humiliation, stress positions, dogs, etc. – were all common torture techniques, right out of the book. 'Walling up' with hoods or blindfolds increases the sense of isolation and defencelessness. Essential to torture is the sense that your interrogators control everything: food, clothing, dignity, light, even life itself. Everything is designed to make it clear that you are at the mercy of those whose job it is not to have any mercy. Hooding victims dehumanizes them, making them anonymous and thing-like. They become just bodies. You can do anything you want to them.[10]

The thing-like character of the seated, bound, hooded body in *Interrogation II* is contrasted with the angular athleticism of the standing torturers; they gaze at us insolently, daring us even to reprove, much less stop them. The physically raw and emotionally extremist theatre depicted in Leon Golub's *Interrogation II* – unlike the artefacts of recent mass culture cited earlier – preclude erotic pleasure. The painting instead describes the emotional insensibility of the torturers, and the complete physical vulnerability of the victim. They draw on an ancient pathos formula in order to expose its artifice and viciousness, turn it upside down, and render it useless as a weapon in the war of the powerful against the vulnerable.

8
Orientalism

In my earlier retelling of Freud's story of the discovery of the parapraxis, I omitted a detail that may provide us with one additional clue to the meaning of the photographs from Abu Ghraib. You will remember that Freud's forgetting of the name of Signorelli as the artist of the Orvieto frescos was the result of his repression of unpleasant news he had received at Trafoi about the suicide of a patient in despair over an incurable sexual disorder. The resemblance between the place names Trafoi and Boltraffio explains why the Milanese painter entered Freud's conscious mind, but it does not account for the repression of the name Signorelli. Freud's explanation hinges on the German word 'Herr' ('sir') and a pair of anecdotes about Turks – which I take to mean Muslims – living in Bosnia and Herzegovina:

> The Turks in that country [a doctor-friend told me], show full confidence in their physician and complete submission to fate. When one is compelled to inform them that there is no help for the patient, they answer: '*Sir* (Herr), what can I say? I know that if he could be saved you would save him.' In these sentences alone we can find the words and names: *Bosnia, Herzegovina*, and *Herr* (sir), which may be inserted in an association series between *Signorelli, Botticelli*, and *Boltraffio*.

The second anecdote related by Freud concerned the sexual habits of the Bosnian Muslims:

These Turks value sexual pleasure above all else, and at sexual disturbances fall into an utter despair which strangely contrasts with their resignation at the peril of losing their lives. One of my colleague's patients once told him: 'For you know, sir (Herr), if that ceases, life no longer has any charm.'

Whatever the adequacy of Freud's explanation of his parapraxis (and no less than Jacques Lacan felt the need to try an alternative interpretation), his two anecdotes expose a predictable Orientalism. In juxtaposing what he understood to be Muslim under-valuation of death, and over-valuation of sex, Freud was reprising both nineteenth-century stereotypes of the harem and – in linguistic form – the ancient pathos formula of the redeemed or beautiful death. This perspective on the Islamic world – that it is populated by men resigned to harsh chastisement or death who nevertheless seek every opportunity for erotic pleasure – underlies, as I have argued, the photographs of Iraqi prisoners at Abu Ghraib.

But the difference between Freud's world-view and that of the guards at Abu Ghraib is much greater than any similarity: for while Freud could repress the disturbing content of his stereotypes and fantasies and redirect its energy, the guards and interrogators at Abu Ghraib had no such capacity. By disposition and by training – indeed by explicit direction from Washington – they were enabled to act immediately on what they saw, felt and desired. The guards at Abu Ghraib were furnished with explicit instructions by the military chain of command to (in the words of Major General Geoffrey D. Miller), 'be actively engaged in setting the conditions for successful exploitation of the internees'.[1] Those 'conditions', determined in Washington and tested at Guantanamo Bay in Cuba, included water-boarding and many other tortures. Right-wing Deleuzians, we may call the guards, desiring-machines stymied in familial, social and economic spheres at home, but let loose in Iraq. Graner, a wife-beater from Pennsylvania and a particularly brutal prison guard in civilian life, is given his head at Abu Ghraib; England, a young woman from rural Cumberland, West Virginia, enlists in the Army Reserves in

order to quit her job at a chicken processing-plant in Moorhead, a factory singled out by PETA (and filmed) because of its particular cruelty to animals. Sent to Iraq in 2003, she finds there an outlet for her repressed desires: she learns to torture and kill, and pairs up with Graner. These are examples of the men and women who have most fully incorporated into their bodies and their minds the pathos formula that I have traced here; these are the people selected – by virtue of aptitude and economic and social vulnerability – to serve in imperial wars; they are the ones who expose pictures of an incipient fascism, manifested by the practice of torture at Abu Ghraib, Guantanamo Bay, Bagram and dozens of other prisons controlled by the US government, some known and some still secret, around the globe.

Afterword:
What is Western Art?

In the preceding eight chapters I have argued that an ancient pathos formula of beautiful suffering – the introversion of subordination – has re-emerged in a surprising place: the minds, eyes and bodies of men and women serving in the US military in Iraq, engaged in a dirty, idiotic and hopeless imperial war. It has also structured the vision of a considerable portion of the US public, rendering them largely mute before the spectacle of officially sanctioned torture at Abu Ghraib and elsewhere. I have called this the 'Abu Ghraib effect'.

But a basic question may still linger in the mind of the reader: does the mythic structure, or pathos formula described here really constitute a core, Western, artistic tradition – or is its appearance in each historical case simply an ad hoc response to a particular national, imperial and military circumstance? When, in other words, does a string of individual occurrences become a line of descent; when does the reiteration of form constitute a pathos formula? The instances cited – at Pergamon, by the artists Michelangelo, Vasari, Bernini and Mukhina, and in racist postcards, Hollywood movies and broadcast television – hardly constitute a seamless or unbroken lineage of forms and images. Indeed, beyond the integrity of the pathos formula, does a Western, Classical tradition exist at all, or is it the manifestation of the self-same Eurocentrism on exhibit in the frightful images from Abu Ghraib?

There is a great deal to be said for the latter proposition; the historical existence of a stable entity called Europe and the West – much less Western Art – cannot be taken for granted. Indeed,

the discipline of art history has long been buttressed by three, highly contestable, even dubious propositions (or 'idols'), which must be examined and criticized before the question of a Classical, Western or European tradition – and a pathos formula – can be evaluated.

The Idol of Development

For more than a century, textbooks and many monographic studies devoted to European Art have celebrated its humanism and affirmed the inevitability of its course. Indeed, the story of art in Europe from the fifth century BCE to the the twenty-first century is still often presented as a narrative of development. In accord with Sir Francis Bacon's paradoxical dictum, '*antiquitas saeculi, juventus mundi*' ('in olden days, the world was young'), art was long understood to have experienced its childhood in Classical Greece, its adolescence in the Christian Middle Ages, and its maturity in the Renaissance. Subsequent periods of art – Mannerism, Baroque and Rococo – reveal a decline in the power and authority of the Classical heritage, while Modernism heralds the re-birth of art, conceived from wholly new materials. This developmental schema – sometimes continuous, sometimes interrupted, and sometimes proceeding in cycles – is itself of great antiquity, with roots in the sagas and histories of Bronze Age Greece. During the European Renaissance of the fifteenth and sixteenth centuries, the belief was given especial credence.

In 1554 Giorgio Vasari began his great book of the lives of the most notable Renaissance artists by stating that he wished to tell the story of how the art of painting was invented by 'primitive men', and of how it advanced 'little by little', suffered setbacks, until it finally achieved perfection in the writer's own day:

> For having seen in what way she, from a small beginning, climbed to the greatest height, and how from a state so noble she fell into utter ruin, and that, in consequence, the nature of this art is similar to that of others, which like human bod-

ies, have their birth, their growth, their growing old, and their death; they will now be able to recognize more easily the progress of her second birth and of that very perfection whereto she has again risen in our times.[1]

Similar formulations are found in writings by many Italian and French biographers and historians of the next century. A somewhat pessimistic version is represented by the French Academician Charles Perrault, who wrote in 1688: 'Is it not true that the development of the world is usually regarded as comparable to that of a man's life, that it has had its infancy, its youth, and its maturity, and is presently in its old age?'[2] The German J. J. Winckelmann, often considered the first true art historian, wrote in his 1755 *Reflections on the Imitation of Greek Works in Painting and Sculpture*: 'The arts themselves have their infancy, as do human beings, and they begin as do youthful artists with a preference for amazement and bombast . . . steadiness and composure follow last.'[3] A century later, Karl Marx also compared human and artistic growth. In an effort to understand the continuing thrall of archaic Greek art in modern times, he speculated that it might represent a longing for 'the historical childhood of humanity, where it had obtained its most beautiful development'.[4] While each of these authors expressed preferences for different phases in the life cycle of history and art – Perrault its maturity, Vasari and Winckelmann its seniority and Marx its childhood – all accepted the validity of the organic model. Such developmental formulas – sometimes stripped of their anthropomorphism – may also be found in writings by a number of art historians from the first decades of the twentieth century – Heinrich Wölfflin, Paul Frankl and Alois Riegl stand out – and they continue to exert an attraction today.

The notion of developmental or evolutionary stages in art history remains a staple of the study of paleolithic, Classical Mediterranean, Renaissance and Pre-Columbian art. The art historian E. H. Gombrich, whose work was very much influenced by the evolutionary perspective of his teacher, Emanuel Löwy, remains widely read by scholars and students of art history and by

the lay public. In *The Story of Art*, first published in 1950, Gombrich starts by discussing the 'strange beginnings' of representational art among cave dwellers and so-called 'primitives'. He then proceeds to describe the 'Great Awakening' of the ancient Greeks, the 'Conquest of Reality' achieved in the Quattrocento and – emulating Vasari – the 'Harmony Attained' by High Renaissance artists. His narrative speeds across the succeeding centuries and ends (somewhat uncertainly), with a chapter called 'A Story without End' emphasizing a theme with which his book began, that 'each generation is at some point in revolt against the standards of its fathers'. Implicit is an assumption that Western culture, including its art, will go on forever in accord with some unspecified internal dynamic and progressive paradigm. The art historian Meyer Schapiro once ridiculed this as 'the grandfather principle', since, taken to its logical extreme, it implies 'the perpetual alternating motion of generations'; artists tend to create works that resemble those created by their grandfathers' generation.[5]

In another broad attempt to organize and survey the Western tradition, Martin Kemp, in his *Oxford History of Western Art*, implicitly rejected the schematic art-historical oscillations of Gombrich, but at the same time embraced a developmental history of art based on the analysis of style, seeing it as 'a powerful and elastic method, equipped with subtle tools of visual analysis'.[6] Though Kemp proposed that this 'traditional art history' be augmented by a feminist interrogation of how women came to negotiate and achieve a role in the making and viewing of art, he nevertheless described the Western tradition as following a logic of progress. He began his textbook with a chapter called 'Foundations' (Greece and Rome), proceeded to explore 'The Establishment of European Visual Culture' (Christian Art from its beginning until the High Renaissance), and continued through to 'Modernism and After'. Underlying this development, Kemp argued, was the growing sense that the creation of 'a beautiful object is a special kind of activity, demanding special abilities from their makers and asking for a special kind of response from their viewers'. The full realization of this exceptional activity and mode

of perception came about after the Renaissance, when artists became self-conscious of their own mastery and started to focus on their own 'creativity, originality and individuality'. Kemp insisted finally, that the same kinds of self-conscious practices that characterized Modernist art of the late nineteenth and early twentieth centuries also mark the making and viewing of art in the present. Though a view from fifty years hence may suggest that a new 'postmodern phase' came to dominate art in the 1960s or '70s, he says, it is unlikely that the basic, Western paradigm will change. Kemp's book exemplifies the model of gradualism, stability and stasis from which this book departs. Though the pathos formula I describe may be observed across more than two millennia, it functioned in very different ways for each regime that sustained it – in one instance buttressing a notion of *basanic* truth, in another Catholic orthodoxy, and in still another racial supremacy. Moreover, at least since the eighteenth century, as we have seen, the formula has been regularly contested by insurgent classes and communities who reject the reigning hierarchies it represents.

The Idol of Progress

The Abu Ghraib Effect is therefore not based on any conception of development or progress in art. Progress is one of the key ideas in modern thought – and a chief obstacle to critical reflection about art – and it has two essential meanings. First, that history – including both natural and human history – moves and develops through time in a steady order and predictable sequence, and that there are no sudden leaps, disruptions or changes in direction. Progress implies that there exists a regularity and even predictability to the functioning of nature and society, and that what is most recent, logically and inevitably follows what was past, and that what was past had best be left behind. This model does not stand up to scrutiny in either the natural sciences or humanistic studies. The discontinuities and contingencies of history are revealed throughout this book: they are seen, for example, in the surprising afterlife in Papal, Renaissance Rome, of a pathos for-

mula that first appeared in the monumental art of an imperialist, pagan Hellenistic court; in the satirical assault by William Hogarth on history painting and the Grand Manner, and the absolute inversion of the meaning of the pathos formula achieved by abolitionist propagandists such as Josiah Wedgwood; and more fully, in the vehemently anti-war, human-rights based imagery of Goya, Picasso, Ben Shahn and many others. In the end, there is no self-sufficient, self-explaining tradition of art, only the history of cultures and civilizations, fiercely constructive and ferociously destructive all at once, that illuminate their irregular course by means of a particularly dazzling spectacle of glory, tragedy, violence and emancipation.

The second meaning of the word progress is proscriptive, not simply descriptive, and is thus especially to be avoided. Progress, according to this definition, is the steady and implacable march toward betterment. This idea flourished in the eighteenth and nineteenth centuries; it is the basis for key French Enlighten - ment texts by Turgot and Condorcet and was used to justify all manner of violence, conquest, and even genocide. But in fact, European, or Western, art has not progressed in a uni-linear fash- ion, has not got gradually better (or worse), and has not represented an increasingly humane and equitable world. Indeed, the art and imagery examined in this book often testifies to a particular propensity for violence on the part of those who control artistic or expressive culture, and those who work for them. All the more compelling therefore, and all the more heroic, were the artists who refused the ideology of progress and oppressive power and instead embraced ideals of civilization and democracy.

There have been ambitious art-historical studies of the Western tradition that seem to have eschewed the model of progress in art. In *The Philosophy of Art History* Arnold Hauser embraced what he termed 'the sociological interpretation of cultural achievements' and rejected any argument that art was 'a closed and complete system in itself'.[7] His insistence that works of art be understood as intimately tied to struggles over class, prestige and status, and that they are bound to the social and political conditions of their own time, would immediately seem to

distinguish his scholarship from the developmental or progress-based approaches outlined above. His additional assertion that works of art be understood as 'nodal points' where society, psychology and style all intersect is an equally independent formulation.[8] Hauser was not content to understand artworks as timeless expressions of individual genius, and had keen insight into what he called 'the ideological character of thought'. Yet Hauser's writings – including both *The Philosophy of Art History* and the four-volume *Social History of Art* – are like Gombrich's in that they are marked by a highly schematic understanding of the relationship between art and society. They also reveal a heavy-handed teleology, stopping just short of the announcement that in an unspecified future, capitalism will collapse and socialism triumph. Indeed, Hauser's texts are not free of progressivist formulas. The history of art according to him, like the history of religion according to the late nineteenth-century anthropologists E. B. Tylor and James Frazer, progressed everywhere through magical, animist, monotheistic and secular phases. (The last phase, in turn, is further divided into a 'courtly aristocratic' and 'bourgeois' duality.) Each period of art expressed 'the spirit of the time', and each historical cycle transcended the previous phase. Artists and their works, in short, are seen by Hauser as illustrations of the predominate ideologies that pre-exist them. The result, it seems to me, is often a sense of art-historical rudderlessness: there are effects without causes, changes without agents, and art without artists. Rather than understanding artworks as directly constitutive of ideology, Hauser tended to see them as mere reflections of the common sense, or received ideas of their time, and as leading invariably to a higher stage of culture.

Underlying all the progressive theories of art history found in these textbooks – whether by Hauser, Kemp or Gombrich, and in almost innumerable monographs – is the geographical and cultural fabulation called Europe and the West. The idea underlying this constriction is that Europe is a coherent cultural and geographical entity, and that it has been uniquely dynamic, creative and progressive. The art of Europe, according to this notion, began in Athens, moved north during the Christian Middle Ages,

blossomed and grew in the Renaissance and Baroque periods, and continued – albeit in an etiolated condition – through the twentieth century. This book represents the view that on the contrary, no single tradition or line of development of European or Western art can plausibly be traced. Nevertheless, many of the works examined here do possess this in common: they manifest particular formal and ideological characteristics that have made them useful to successive generations of dominant classes, groups and individuals. They thus constitute a significant basis for the Classical tradition, lionized by academic artists and elite patrons and assailed by modern artists and their supporters in the nineteenth and twentieth centuries.

The Idol of Europe

The geographers tell us that Europe is a continent, separated from Asia by the Ural Mountains on the east, and by the Caucasus Mountains, and Black and Caspian Seas on the Southeast. To the west of Europe lies the Atlantic Ocean and the Americas, and to the north the frigid zones of the Arctic. Yet in fact this definition of Europe – an aspect of what has been dubbed 'the myth of continents' – is highly arbitrary and only a few centuries old.[9] The landforms of Europe – its glaciated plains and lowlands, its hills, plateaux and mountains – each extend well to the East and to the South. The vegetation belts, corresponding to the climatic zones – coniferous, deciduous, tundra, steppe and so on – also bear no perceptible relation to the old continental definition. The Mediterranean basin must logically include North Africa as well as what is now Spain, France, Italy, Greece, Turkey and the Balkans, and the Steppes of Europe extend far into Asia. In addition, while Europe has been termed a continent, India (with a vastly greater population) is considered just a subcontinent, while China (which exceeds Europe as well as India in both size and population) is merely a country. Europe has sometimes been called, more or less correctly, a peninsula of Asia, but such an ascription actually undervalues its connections to Africa. A better

geographical subdivision of the world would probably include an entity that the historian Andre Gunder Frank calls 'Afro-Eurasia', but that would raise further questions concerning where Asia and Africa begin and end, and lead once again to an impasse.[10]

For any definition of Europe or the West to have cogency therefore, it must have cultural historical validity. Yet as coherent as European culture and European art may sound, the terms are actually fairly new inventions. Though the word Europe may be traced back at least to the ancient Assyrian *ereb* or *irib*, which means 'land of darkness', it has generally lacked any stable linguistic or cultural definition. In the fifth century BCE, Aeschylus drew a distinction between Europe and Asia, but he was actually only marking the difference between East and West. Two centuries later, Eratosthenes spoke of Europe as coincident with all of Asia. The Greeks themselves were by no means certain that they were part of Europe. (They did not even have a clear sense of being Greek; their identities and loyalties were much more narrowly circumscribed: they were Athenians, Spartans or Thebans; at most they might consider themselves part of regional alliances, such as the Delian League.) The ancient world consisted of dozens of distinct civilizations separated by thousands of miles. To speak of them as European or Western makes no sense.

The peoples and cultures of the Christian Middle Ages in Northern and Central Europe did not consider themselves European either. In order for them to have done so, they would have needed to possess a greater knowledge of the non-European world than they had. (That knowledge arose only very slowly with the reports of Papal envoys to the Mongols in the mid-thirteenth century, the Marco Polo adventure a few decades later, and the expansion of trade in the fourteenth century to the Mongol Empire and China.) Moreover, European Christians largely rejected any notion that they were imbued with the heritage of Greco-Roman antiquity. Instead, they embraced the legacy of an extremely different cultural, economic and political context – that of Israel, the Hebrews and the early Church. During the Renaissance, these dual legacies – one Greco-Roman and polytheistic, and the other Middle Eastern and monotheistic – were

brought together. The union required lots of ideological cement, and for the first time established some bases for the creation of the idea of Europe and the West. The embrace of the culture and geography of both ancient Rome and Israel demanded the removal of Islam from the world of the Middle East and North Africa. This was a difficult ideological (and military) feat, and in fact many of the greatest Renaissance artists and writers continued to accept and record their indebtedness to the knowledge preserved and created beneath the banner of the star and crescent of Islam.

In Dante's *Inferno,* the first circle of Hell is occupied not just by the virtuous heathens Homer, Socrates and Plato, but by the great Arab-Islamic scholars Ibn Sina, Ibn Rushd and Salah ad-Din all of whom had the opportunity to embrace Christ, but chose not to do so. If they nevertheless escaped the lowest rings of Hell (Muhammed himself is placed in the eighth and ninth circles), it must be because Dante respected their rationalism, empiricism and humanism. In Raphael's fresco called *The School of Athens* in the Vatican Palace, literally the most canonical painting of the Italian Renaissance, it is a turbaned philosopher – possibly Ibn Rusd ('Averroës' in English) – who leans solicitously over the left shoulder of the Greek Pythagorus. The wisdom of the ancients, Raphael suggests, was passed down by Islamic scholars, not by European Christian scholastics. By the mid- and later eighteenth century, admiration for the Middle East, or what was then called 'the Orient', came to be tinged with racism. Soon, the Muslim world would be cast out of Europe and the West altogether. Buttressed by colonial conquests in North Africa and the Ottoman East, historians, philologists, social scientists and art historians argued that social and cultural developments are largely autochthonous, that is, internal to nations and societies themselves, and that all societies are either rising or declining. If the French were occupying Morocco and Algeria, then it must be because of the degeneracy or stagnancy of Islamic society as compared to the growth and vibrancy of Christian Europe. Whereas the West was marked by the growth of modern industry, the Orient was disfigured by an ancient military hierarchy; whereas

Europe had a rational system of state legitimation based on the rule of law, Islam and the Far East had a traditional order based on despotism; whereas the one was dynamic, the other was static, whereas the one was progressive, the other was reactionary. Europe represented all that was modern; the East represented everything that was past.

This book obviously does not solve, or even seriously address, the geographical and cultural dilemmas posed by this criticism of the concept of Europe and the West. Accepting that the latter term lacks empirical validity, I would nevertheless propose that it has instead all of the attributes of what Durkheim called a social or 'moral fact'.[11] Europe is in most ways a geographical, historical and cultural fiction, and yet for at least half a millennium it has functioned as a coercive force, a 'rule of sanctioned conduct'. Membership in Europe, or access to the cultural traditions defined as classical, has conferred palpable benefits on narrow subsets of the population. Exclusion from the club on the other hand – by virtue of one's sex or sex preferences, class, religion, ethnicity or geographical location – has resulted in all kinds of chastisements. The long history of Western art briefly related in this book is therefore part of the history of the construction of Europe and the United States itself, and the story too, of periodic efforts at its disassembly.

When the Indian emancipator Mahatma Gandhi was asked 'What do you think of Western civilization?', he famously retorted 'I think it would be a good idea.' In this text, I ask the same question about European art and Western enlightenment, and give a similar reply: 'An "Age of Reason" (one of Gombrich's chapter titles) would be a good idea.' If in fact there is any essential continuity to Western art during the past half-millennium, it is that many of its greatest artistic monuments have either depended on the unaccounted toil of oppressed men and women, or else justified and even made beautiful human suffering. In thus highlighting, as stated earlier, the triumphal procession of victors carrying their artistic booty, this book may be distinguished from those by other recent art historians who have surveyed the long tradition of Western art and re-presented it to students and

general readers. For them, art is 'the tangible evidence of the ever-questing human spirit', the expression of 'its creators' deepest understanding and highest aspirations', and the representation 'in myriad arresting forms, [of] the highest values and ideals of the human race'.[12]

A more dispassionate perspective on the history of art, as I have tried to sketch in this book, reveals that though art in Europe and the West most frequently functioned as a handmaiden to arrogance, power and violence – articulating a pathos formula of internalized subordination and eroticized chastisement – there were moments when its makers saw through the charade of authority and alienation, and envisaged the possibility of freedom, community, justice and democracy as lived ideals rather than ideological covers of authority. The goal here, finally, has been to brush art history against the grain, that is, to encourage readers to resist the often oppressive thrall of the familiar and beloved images, objects and monuments of Western art history and modern media culture. The goal is also to prompt wonder and admiration at the achievement of a limited number of artists who acted against the instrumental and oppressive authority of the Western pathos formula.

References

epigraphs

1 *Convention Against Torture and Other Cruel, Inhuman or Degrading Treatment or Punishment* part 1, article 1, no. 1; article 2, no. 2; article 3, no. 1; adopted 10 December 1984, S. Treaty Doc. No. 100–120,1988, 1465. Entered into force 26 June 1987. For the full text and US reservations, see www.unher.ch/html/menu3/b/h_cat39.htm.
2 Walter Benjamin, *Illuminations*, trans. Harry Zohn, ed. Hannah Arendt (New York, 1969), pp. 255–7.

Preface

1 The full archive of the visual documentation of torture and abuse at Abu Ghraib prison – in the form of a single DVD – was made available to Salon.com on 16 February 2006. According to the report of Special Agent James E. Seigmund of the US Army's Criminal Investigation Command, 'a review of all the computer media submitted to this office revealed a total of 1,325 images of suspected detainee abuse, 93 video files of suspected detainee abuse, 660 images of adult pornography, 546 images of suspected dead Iraqi detainees, 29 images of soldiers in simulated sexual acts, 20 images of a soldier with a swastika drawn between his eyes, 37 images of Military Working Dogs

being used in abuse of detainees and 125 images of questionable acts'. http://www.salon.com/news/feature/2006/02/16/abu_ghraib/.

2 See the comprehensive report of the Detainee Abuse and Accountability Project (DAA Project), prepared by the Center for Human Rights and Global Justice at NYU School of Law, Human Rights Watch and Human Rights First: http://www.humanrightsfirst.info/pdf/06425-etn-by-the-numbers.pdf

3 The notorious death of a 'ghost' (undocumented) detainee named Manadel al-Jamadi at Abu Ghraib prison, well-documented by Abu Ghraib photographs and extensive testimony, resulted in accusations against ten Navy personnel. Nine received non-judicial punishment – rank reductions and letters of reprimand – and a tenth was acquitted. (DAA Project, Appendix B.)

4 Poll results reported in http://www.publicagenda.org/specials/terrorism/terror.htm; www.abcnews.go.com/us/wirestory?id=1378454.

5 This is not a question of the quality of the pictures or the skill of the photographers. Adolf Hitler was arguably a worse painter than the guards at Abu Ghraib were photographers, but his landscapes and cityscapes were clearly works of art; he intended them to be exhibited, seen, discussed and purchased as works of art, and they were. Now they are banal tokens of an emerging evil. On Hitler's career as an artist, see O. K. Werckmeister, 'Hitler the Artist', *Critical Inquiry*, XXIII/2 (Winter 1997), pp. 270–97.

1 Resemblance

1 Seymour Hersh, 'Torture at Abu Ghraib', *The New Yorker*, 10 May 2004: www.newyorker.com/printables/fact/040510fa_fact; also see his *Chain of Command: The Road from 9/11 to Abu Ghraib* (New York, 2004); CBS *60 minutes II*, 28 April 2004.

A rare exception is the brief discussion by the Lebanese architect Samia Nassar Melk, who compared the photograph of a naked prisoner with back to the viewer and arms outstretched to unspecified works by Caravaggio and to Bernini's *David*. See Samia Nassar Melki, 'A Letter from Beirut, Caravaggio in Iraq', *Counterpunch*, 3 June 2004, http://www.counterpunch.org/melki06032004.html.

3 The comparison was made by Jeff Sharlet, 'Pictures from an Inquisition', *The Revealer: A Daily Review of Religion and the Press*, 30 April 2004, located at: http://www.therevealer.org/archives/revealing_000355.php.

4 The text (in translation) on Goya's figure reads: 'They put a gag on her because she talked. And struck her in the face. I saw her, Orosio Moreno, in Saragossa. For knowing how to make mice. The charge is one that might have been made against someone for witchcraft.' Juliet Wilson-Bareau, *Goya: Drawings from his Private Albums* (London, 2001), pp. 180–81.

5 An exception would be Italian Futurism, which upheld the dynamic beauty of power, machinery and warfare. 'A racing automobile', the poet Marinetti wrote in 1909, 'its hood adorned with great pipes like snakes with explosive breath . . . which seems to run like a machine gun, is more beautiful than the *Victory of Samothrace*'.

6 I include among these modern artworks those that highlight objectification or 'self-alienation' (see text and note 11, below) – such as by Seurat, Leger, Mondrian and others – in order to enable individuals to see, understand and potentially reject their own alienation. See Michael W. Jennings, *Dialectical Images: Walter Benjamin's Theory of Literary Criticism* (Ithaca, NY, 1987), p. 172; cited in Miriam Bratu Hansen, 'Room-for-Play: Benjamin's Gamble with Cinema', *October* 109 (Summer 2004), p. 25.

7 Sigmund Freud, *The Uncanny*, trans. David McLintock (London and New York, 2003), p. 148.

8 Stephen Eisenman and Karl Werckmeister, *Culture and Barbarism: A History of European Art* (unpublished manu-

125

script), n.p. Werckmeister's formulation has proved central to my own understanding of the Abu Ghraib photographs. Also see Otto Karl Werckmeister, *Der Medusa Effekt: Politische Bildstrategien seit dem 11. September 2001* (Berlin, 2005). My title is intended as homage to his fine book.

9 The US repression of Filipino resistance is an instructive historical example. See the historical summary contained in John Bellamy Foster, Harry Magdoff and Robert W. McChesney, 'Kipling, the "White Man's Burden" and US Imperialism', in *Pox Americana: Exposing the American Empire*, ed. John Bellamy Foster and Robert W. McChesney (New York, 2004), pp. 13–18. For an account of water torture in Vietnam (regularly used in Iraq), see Jonathan Schell, *The Real War: The Classic Reporting on the Vietnam War* (New York, 2000), pp. 114–15. On torture in Chicago, see John Conroy, *Unspeakable Acts, Ordinary People: The Dynamics of Torture* (Berkeley and Los Angeles, 2001). On 11 May 2006 the United Nations Committee Against Torture released an eleven-page report outlining a long-term pattern of torture and abuse by Chicago Police against black suspects.

10 E. H. Gombrich, *Aby Warburg: An Intellectual Biography* (London, 1970), pp. 244–5. Also see Felix Gilbert, 'From Art History to the History of Civilization: Gombrich's Biography of Aby Warburg', *The Journal of Modern History*, XLIV/3 (1972), pp. 381–91.

11 Michael Taussig, 'Culture of Terror – Space of Death: Roger Casement's Putumayo Report and the Explanation of Torture', *Comparative Studies in Society and History*, XXVI/3 (1984), p. 470.

12 Duncan Campbell, 'Kissinger approved Argentinian "dirty war"', *The Guardian*, 6 December 2003, p. 1; also see *When States Kill: Latin America, the US, and Technologies of Terror*, ed. Cecilia Menjivar and Nestor Rodriguez (Austin, TX, 2005).

2 Freudian Slip

1 See the collection of articles, chat and links organized by *Jump Cut* (www.ejumpcut.org/currentissue/links.html) and the *16 Beaver Collective* (www.16beavergroup.org/monday/archives/001354.php).
2 Walter Benjamin, *Illuminations*, p. 242.
3 Among the many examples is the exhibition, organized by Nina Felshin at the Ezra and Cecile Zilkha Gallery at Wesleyan University from 9 September to 11 December 2005, which included works by Jacques Callot, Goya and Leon Golub. It was accompanied by Brian Wallis's exhibition *Inconvenient Evidence: Iraqi Prison Photographs from Abu Ghraib*. Curated and co-organized by the International Center of Photography in New York and The Andy Warhol Museum in Pittsburgh.
4 Reference to Goya's *Disasters* is found, for example, in *Abu Ghraib: The Politics of Torture*, with essays by Meron Benvinisti et al. (Berkeley, CA, 2004), p. 90.
5 Goya was undoubtedly aware of the publication in 1812 of the first volume of Juan Antonio Llorente's reformist *Historia critica de la inquisition de Espana*, and a little later the *Memorias para la historia de la revolution Espanol*. Also see Goya's *Portrait of Don Juan Antonio Llorente*, *c*. 1810–12, Museu de Arte de São Paulo.
6 Juan Antonio Llorente, *The History of the Inquisition of Spain* (Philadelphia, PA, 1843), pp. 203–6.
7 Cesare Beccaria, *An Essay on Crimes and Punishments*, trans. E. D. Ingraham (Philadelphia, PA, 1819), p. 105.
8 See for example the remarks of Ian McEwan, cited by Christopher Hitchens in slate.com, 9 May 2005, http://www.slate.com/id/2118306/. Also see the comments of Gijs van Hensbergen, comparing the Abu Ghraib photographs with works by both Goya and Picasso, in *RA*, winter 2004, online at http://www.ramagazine.org.uk/index.php?pid=196.
9 'No one would have ever remembered the horrors of

Guernica if not for the painting', said Fernand Botero, discussing his new works depicting the tortures at Abu Ghraib. Cited in Dan Molinski, 'Botero's Latest Muse: Abu Ghraib', *The Washington Post*, 13 April 2005, p. 10.

10 Comparisons with Bacon have occurred mostly on blogs, including *A Good War is Hard to Find*: http://goodwar.blogspot.com/2005_09_01_goodwar_archive.html, and *Jump Cut*: http://www.ejumpcut.org/archive/jc47.2005/links.html.

11 See the cover of *The Nation*, 26 December 2005, discussed below.

12 Thomas Allnutt Brassey, ed., Brassey's *Annual: The Armed Forces Year-book* (New York, 1961), p. 47; Wilhelm Heitmeyer and John Hagan, eds, *International Handbook of Violence Research* (Dordrecht, Netherlands, 2003), p. 189. Also see Gerry Adams, 'Abu Ghraib is No Surprise to Irish Republicans, I Have Been in Torture Photos Too', *Counterpunch*, 5–6 June 2004, http://www.counterpunch.org/adams06052004.html

13 *Report of the International Committee of the Red Cross (ICRC) on the Treatment by the Coalition Forces of Prisoners of War and Other Protected Persons by the Geneva Conventions in Iraq During Arrest, Internment and Interrogation* by Delegates of the International Committee of the Red Cross, February 2004; cited in Mark Danner, 'Torture and Truth', *The New York Review of Books*, 12 May 2004, reprinted at: http://www.markdanner.com/nyreview/061004_Torture_Truth.htm.

14 A full account of the massacres at Lidice are contained in the transcripts of the Nuremberg War Tribunal, The Trial of German Major War Criminals Sitting at Nuremberg, Germany, 14 February–26 February 1946; Sixty-First Day: Monday, 18 February 1946 (part 3 of 7), pp. 86–8; electronically archived at: http://www.nizkor.org/.

15 Reprisals against civilians also occurred in the town of Haditha, in the Sunni dominated Anbar Province in March 2006. After the death of one soldier from a roadside bomb,

at least 24 civilians – including women and children – were shot to death by Marines. Tom Shanker, Eric Schmitt and Richard A. Opell Jr., 'Military to Report Marines Killed Iraqi Civilians', *The New York Times*, 26 May 2006, p. 1.

16 On 10 November 2005, the US State Department issued a bulletin (correcting a bulletin issued 10 December 2004), admitting use of chemical, phosphorous shells (an outlawed, chemical weapon when used on human targets), but claimed they were used only 'for screening purposes, i.e., obscuring troop movements and . . . as a potent psychological weapon against the insurgents in trench lines and spider holes'. See http://usinfo.state.gov/media/Archive_ Index/Illegal_Weapons_in_Fallujah.html. The charge that the US used napalm (gasoline, benzene and polystyrene) or its equivalent, Mark-77 (kerosene, benzene and polystyrene) firebombs in Fallujah remains disputed. See *The Christian Science Monitor* (online edition), 8 November 2005, http://www.csmonitor.com/2005/1108/daily Update.html. In the same bulletin the State Department admitted to the use of Mark-77 during the initial siege of Baghdad in August 2003.

17 UNHCR Iraq Supplementary Appeal, February 2005, www.unhcr.org. By late 2006 the number of Iraqis thought to have fled the war is more than one million.

18 The frequency and vehemence of condemnations and prohibitions by religious authorities of the viewing of pornography are sufficient to indicate how widespread is the practice. See for example: Muhammad Saed Abdul-Rahman, *Islam: Questions and Answers – Character and Morals* (eBooks, 2003), pp. 36–8.

19 Susan J. Brison, 'The torture connection: when photographs from Abu Ghraib can't be distinguished from "good old American pornography" it's not just the torture we should be questioning', *The San Franciscan Chronicle*, 25 July 2004, http://sfgate.com/cgi-bin/article.cgi?file= /chronicle/archive/2004/07/25/CMGF77DFKCI.DTL%0D. On the MacKinnon debate, see Adele Stan, ed., *Debating*

Sexual Correctness: Pornography, Sexual Harassment, Date Rape and the Politics of Sexual Equality (New York, 1995). On theories of sexual violence, see Jayne Mooney, *Gender, Violence and the Social Order* (New York, 2000). The debate on a possible link between violence and pornography was spurred in part by a sequence of conflicting presidential, congressional and cabinet reports: President's Commission on Obscenity and Pornography. *Report of The Commission on Obscenity and Pornography* (Washington, DC, 1970); Congress, Senate Committee on the Judiciary. Subcommittee on Juvenile Justice, *Effect of Pornography on Women and Children* (Washington, DC,1985); US Department of Justice, *The Attorney General's Commission on Pornography: Final Report* (Washington, DC, 1986).

20 Catherine MacKinnon's argument about pornography goes further, since she insists that it is only a special case of the generalized subordination of women to men in society that robs the former of volitional authority in every sphere of life. Pornography is noteworthy because the realm of the sexual and the erotic is emotionally wrought and especially marked by male domination. Just as no one can reasonably doubt, MacKinnon argues (in Brison, 'The Torture Connection', n.p.) that the naked men in the Abu Ghraib photographs have been coerced, so no one should doubt that the women in pornography have been forced to perform the depicted sex acts. See Donald Alexander Downs, *The New Politics of Pornography* (Chicago, IL, 1989), pp. 38–41.

21 An alternative perspective, emphasizing the self-consciousness and economic rationality of actors and actresses in the porn industry, is found in Sharon A. Abbott, 'Motivations for Pursuing an Acting Career in the Sex Industry', in *Sex for Sale: Prostitution, Pornography and the Sex Industry*, ed. Ronald John Weitzer (London, 2000), pp. 17–35.

22 Rochelle Gurstein, 'On the Triumph of the Pornographic Imagination', *The New Republic Online*, 15 May 2005: https://ssl.tnr.com/p/docsub.mhtnl?I=w050516&s=gurst eino51805.

23 Arthur Danto, 'Art and Politics in American Self-Consciousness', *Artforum*, July 2004, republished at: http://www.16beavergroup.org/monday/archives/001354. php.

24 http://www.16beavergroup.org/mtarchive/archives/ 001084.php.

25 See the essays and annotated bibliography in Linda Williams, ed., *Porn Studies* (Durham, 2004).

26 See Laura Kipnis, *Bound and Gagged: Pornography and the Politics of Fantasy in America* (Durham, NC, 1999); F. Attwood, 'Reading Porn: The Paradigm Shift in Pornography Research', *Sexualities*, 5 (2002), 91–105.

27 Homi Bhabha, *The Location of Culture* (New York, 1990), p. 85.

28 *New York Times*, 11 May 2004, re-published online at http://www.pen.org/viewmedia.php/prmMI.

29 Susan Sontag, 'Regarding the Torture of Others', *The New York Times*, 23 May 2004, found at: http://select.nytimes. com/search/restricted/article?res=FA0914F63E5B0C708EDD AC0894DC404482.

30 Abigail Solomon-Godeau, 'Remote control: Abigail Solomon-Godeau's dispatches from the image wars', *Artforum* (Summer 2004), at http://www.artforum.com/ inprint/id=6942?sid=5b35542af12a0e26e6e0bb8104766e7b.

31 Dora Apel, 'Torture culture: lynching photographs and the images of Abu Ghraib', *Art Journal* (Summer 2005), p. 88. Also see her *Imagery of Lynching: Black Men, White Women, and the Mob* (New Brunswick, NJ, 2004).

3 Documents of Barbarism

1 See Slavoj Zizek's discussion of the 'unknown known', the unconscious knowledge of US torture and depravity: 'What Rumsfeld doesn't know that he knows about Abu Ghraib', 21 May 2004; www.inthesetimes.com/site/main /article/what_rumsfeld_doesn't_know_that_he_knows_

about_abu_ghraib.

2　Sigmund Freud, *The Psychopathology of Everyday Life*, trans. James Strachey (London, 1960), passim. See Margaret E. Owens, 'Forgetting Signorelli: Monstrous Visions of the Resurrection of the Dead', *American Imago*, 61/1 (2004) 7–33. Also see Sara Nair James, 'Penance and Redemption: The Role of the Roman Liturgy in Luca Signorelli's Frescoes at Orvieto', *Artibus et Historiae* XXII/44 (2001).

3　Walter Benjamin, *Illuminations*, pp. 256–7 (translation slightly amended by the author).

4　Nigel Spivey, *Enduring Creation: Art, Pain and Fortitude* (Berkeley and Los Angeles, CA, 2001), p. 34.

5　Page duBois, *Torture and Truth* (New York, 1991).

6　Edward Peters, *Torture* (Philadephia, PA, 1999), passim. See Foucault's unpublished lectures on Greek *parrhesia* ('speaking frankly'), an attribute of free citizens, not of slaves. These texts derive from Foucault's last seminar at UC Berkeley during Fall 1983; they have been transcribed at http://foucault.info/documents/parrhesia/.

7　David C. Mirhady, 'Torture and Rhetoric in Athens', *Journal of Hellenic Studies*, CXVI (1996), p. 130.

8　Aristotle on Rhetoric – George A. Kennedy, trans., ed., *A Theory of Civic Discourse* (Oxford and New York, 1991), p. 115.

9　Edith Hall, *The Classical Review*, n.s., XLIII/1 (1993), p. 126. Also see Michael Gagarin, ed., *Antiphon: The Speeches* (Cambridge, 1997), p.22.

10　Peters, *Torture*, pp. 17–18.

11　Aristophanes, *The Frogs*, trans. B. B. Rogers (New York,1909–14), vol. VIII, pt 9, ll. 424–44.

12　Perry Anderson, *Passages from Antiquity to Feudalism* (London, 1974), pp. 41–4.

13　Roger S. Bagnall and Peter Derow, eds, *The Hellenistic Period: Historical Sources in Translation* (Oxford, 2004), p. 236; Richard A. Billows, *Kings and Colonists: Aspects of Macedonian Imperialism* (Leiden and New York, 1994), p. 44.

14 Anderson, *Passages*, p. 49.
15 J. J. Winckelmann, *The History of Ancient Art*, trans. G. Henry Lodge (Boston, 1880), II, p. 231.
16 A. A. Long and D. N. Snedley, eds, *The Hellenistic Philosophers* (Cambridge, 1987); Michael Steinberg, *The Fiction of a Thinkable World, Body, Meaning and the Culture of Capitalism* (New York, 2005), pp. 80–92.
17 Cicero, 'Tusculan Dissertations, Books III and IV', in *Cicero on the Emotions*, ed. and trans. Margaret Graver (Chicago, 2002), p. 65.
18 Peters, *Torture*, p. 44. St Paul argued that all believers are slaves to Christ, and that true Christians must embrace chastisement and enslavement, if that be their fate: 'Even supposing you could go free, you would be better off making the most of your slavery.' St Augustine believed that all people were deserving of enslavement and punishment because all were sinners. 'The first cause of slavery is sin', he wrote, and slaves can 'make their slavery, in a sense, free, by serving [their masters] not with the slyness of fear, but with the fidelity of affection, until all injustice disappears and all human lordship and power is annihilated, and God is all in all'. *City of God*, book XIX, chap. 16. For Augustine, might makes right and the enslaved or the punished attains spiritual freedom by loving his or her master or torturer, and waiting patiently for the Resurrection. The principle was invoked during the period of the Crusades and the Inquisition. The latter was the creation of Pope Gregory IX in the thirteenth century, but it was the Spanish King Ferdinand and Queen Isabella and the Renaissance popes – Sixtus IV, Alexander VI, Innocent VIII, Julius II and Leo X – that unleashed its full fury, coincident with a series of crusades against Muslims and Jews in the fourteenth, fifteenth and sixteenth centuries. On the influence of Hellenistic sculpture on the art of Bernini and the Baroque, see S. Howard, 'Identity and Image Formation in the Narrative Sculpture of Bernini's Early Maturity', *Art Quarterly*, II/2 (1979), pp. 140–71.

19 Aby Warburg, *The Renewal of Pagan Antiquity*, trans. David Britt (Los Angeles, 1999), p. 558. On Warburg's understanding of empathy and of the Renaissance as a locus of a dialectic of pre-modern and modern, Dionysian and Appolonian, see Matthew Rampley, 'From Symbol to Allegory: Aby Warburg's Theory of Art', *The Art Bulletin*, LLXXIX/1 (1997), pp. 41–55

20 Gombrich, *Aby Warburg*, pp. 244–5. Also see Felix Gilbert, 'From Art History to the History of Civilization: Gombrich Biography of Aby Warburg', *The Journal of Modern History*, XLIV/3 (September, 1972), pp. 381–91.

21 Michael Diers, 'Warburg and the Warburgian Tradition of Cultural History', *New German Critique*, no. 65 (Spring, 1995), p. 72.

22 Claude Lévi-Strauss, *Structural Anthropology*, trans. Claire Jacobson (New York and London,1963), p. 210; p. 223.

23 Beryl Rawson, *Children and Childhood in Roman Italy* (Oxford and New York, 2003), p. 58.

24 Anderson, *Passages*, p. 78.

4 Pathos Formula

1 Winckelmann, *The History of Ancient Art*, pp. 130–42.

2 Joshua Reynolds, *Discourses Delivered to Students of the Royal Academy*, ed. Roger Fry (London, 1905), p. 441.

3 Leonard Barkan, *Unearthing the Past: Archaeology and Aesthetics in the Making of Renaissance Culture* (New Haven and London, 1999).

4 Edith Balas, 'Michelangelo's Florentine Slaves and the S. Lorenzo Façade', *The Art Bulletin*, LXV/4 (1983), pp. 665–71.

5 Giorgio Vasari, *Lives of the Most Eminent Painters, Sculptors and Architects*, IV (New York, 1897), p. 71. See Erwin Panofsky, 'The First Two Projects of Michelangelo's Tomb of Julius II', *The Art Bulletin*, XIX/4 (1937), pp. 562.

6 Charles L. Stinger, *The Renaissance in Rome* (Bloomington,

1998), pp. 106–23.

7 Richard Cocke, 'Michelangelo and the Dying Gaul in Naples', *Zeitschrift für Kunstgeschichte*, XLVIII/1 (1985), pp. 109–16.

8 Leo Steinberg, *The Sexuality of Christ in Renaissance Art and in Modern Oblivion* (New York, 1984).

9 Samuel Y. Edgerton, Jr., *Pictures and Punishment: Art and Criminal Prosecution during the Florentine Renaissance* (Ithaca and London, 1985), p. 188.

10 J. A. Symonds, *Renaissance in Italy* (London, 1899), p. 501.

11 Marcia Hall, ed., *Rome (Artistic Centers of the Renaissance)* (Cambridge, 2005), pp. 262–3.

12 *City of God*, book XIX, chap. 16.

13 On the origin of propaganda, see Evonne Anita Levy, *Propaganda and the Jesuit Baroque* (Berkeley and Los Angeles, CA, 2004).

14 José Rabasa, *Writing Violence on the Northern Frontier* (Durham, NC, 2000), p. 144.

5 Stages of Cruelty

1 Leo Bersani and Ulysse Dutoit, *The Forms of Violence: Narrative in Assyrian Art and Modern Culture* (New York, 1985), p. 37.

2 Susan Koslow, 'Law and Order in Rubens's Wolf and Fox Hunt', *The Art Bulletin*, LXXVIII (1996), pp. 680–706.

3 Adam Hochschild, *Bury the Chains* (Boston and New York, 2005), p. 129. Also see Albert Boine, *Art in an Age of Revolution, 1750–1800* (Chicago and London, 1989), pp. 289–94; 306–8.

4 Charles Baudelaire, 'On the Heroism of Modern Life', from the Salon of 1846, in *Art in Paris*, ed. Jonathan Mayne (London, 1964), p. 118.

6 Muscle and Bone

1 Cited in Toby Miller, 'James Bond's Penis', *The James Bond Phenomenon: A Critical Reader*, ed. Christoph Lindner (Manchester, 2003), p. 236.
2 Cited in Jeremy Black, *Politics of James Bond: From Fleming's Novels to the Big Screen* (Omaha, 2005), p. 174.
3 Umberto Ecco, 'The Narrative Structure in Fleming', in *A Critical and Cultural Theory Reader*, eds Kate Easthope et al. (Toronto and Buffalo, 2004), p. 24.
4 Richard Kim, 'Pop Torture', *The Nation*, CCLXXXI/22 (2005), p. 38.
5 Lara Jales Jordan, 'Chertoff Says Homeland Security No "24"', *WashingtonPost.Com*, 23 June 2006. http://www.washingtonpost.com/wp-dyn/content/article/2006/06/23/AR2006062301200.html.
6 Kalpana Seshadri-Crooks, *Desiring Whiteness: A Lacanian Analysis of Race* (London, 2000), pp. 79–103.
7 www.whitepride.com/start.html; www.freedomsite.org/hf/index.html.
8 'The Abu Ghraib Files', Salon.Com, 16 February 2006, http://www.salon.com/news/abu_ghraib/2006/03/14/chapter_1/index.html.
9 Cited in Lila Rajiva, *The Language of Empire: Abu Ghraib and the American Media* (New York, 2005), pp. 28–9.
10 See below, chap. 7, ref. 3.
11 Paul Connerton, *How Societies Remember* (Cambridge, 1989), pp. 72–104.

7 Theatre of Cruelty

1 Michael Taussig, 'Culture of Terror', p. 470.
2 Louis Proyect, *Looking Back at The Battle of Algiers*, MRzine, 8 December 2005, athttp://mrzine.monthlyreview.org/proyect120805.html.
3 http://abcnews.go.com/WNT/Investigation/story?id

=1356870. Also see the government memos approving 'Category III techniques', including 'the use of a wet towel to induce the misperception of suffocation' reprinted in Karen Greenberg and Joshua L. Dratel, eds, *The Torture Papers* (Cambridge and New York, 2005), pp. 235–39.

4 House of Commons Sessional Papers, 14 Feburary 1912–7 March 1913, vol. LXVIII, p. 17.

5 Ibid., p. 39.

6 Henri Alleg, *The Question* (New York, 1958), pp. 60–61.

7 On the US training of Salvadoran's responsible for the murders at El Mozote, see Lesley Gill, *The School of the Americas: Military Training and Political Violence in the Americas* (Durham, NC, 2004), p. 12.

8 See Marc Danner, *The Massacre at El Mozote* (New York, 2004).

9 On the theatricality of torture in the art of Golub, see the forthcoming dissertation of Amber Travis (Northwestern University).

10 David Levi Strauss, 'Inconvenient Evidence: The Effects of Abu Ghraib', *The Brooklyn Rail*, January 2005: http://www.thebrooklynrail.org/spotlight/jan05/abughraib.html

8 Orientalism

1 Greenberg and Dratel, *The Torture Papers*, p. 409.

Afterword: What is Western Art?

1 Giorgio Vasari, *Lives of the most Eminent Painters, Sculptors and Architects*, I (London, 1912–14), p. lvii.

2 Jacques LeGoff, *History and Memory*, trans. S. Randall and E. Claman (New York, 1992), p. 31.

3 Donald Preziosi, ed., *The Art of Art History: A Critical Anthology* (Oxford and New York, 1998), p. 36.

4 Karl Marx and Friedrich Engels, *On Literature and Art*, ed. Lee Baxandall and Stefan Morawski (New York, 1977), p. 136.

5 Meyer Schapiro, 'Nature of Abstract Art', in *Modern Art: 19th and 20th Century* (New York, 1978), p. 188.

6 Martin Kemp, *The Oxford History of Western Art* (Oxford, 2000), p. 4.

7 Arnold Hauser, *The Philosophy of Art History* (New York, 1959), p. 3.

8 Ibid., p. 9.

9 Martin W. Lewis and Karen Wigen, *The Myth of Continents* (Berkeley, CA, 1997), passim.

10 Andre Gunder Frank, *ReOrient, Global Economy in the Asian Age* (Berkeley, CA, 1998), p. 2.

11 Emile Durkheim, *The Division of Labor in Society*, trans. George Simpson (New York, 1964), p. 425.

12 Marilyn Stokstad, *Art History* (New York, 1999), p. 28; H. W. Janson, *History of Art* (New York, 1986), p. 17; *Gardner's Art Through the Ages* (New York, 1991), p. 21.

Acknowledgements

This book began with an invitation from James Elkins to speak at a conference in Cork, Ireland, dedicated to the theme of 'Representations of Pain'. The Abu Ghraib pictures had just been released and it seemed important to me then, as it does now, that art historians – scholars especially trained in the history of images and the history of seeing – do their best to understand these and other terrible images of torture and degradation. I am grateful to Jim for the opportunity to speak and for his many insights. In Ireland, Dora Apel became for me a good friend and comrade. Her work on photographs of American lynching is historically and ethically exemplary, and her lecture (and later article) about the relationship between them and the Abu Ghraib images was insightful. A opportunity to test my ideas before students was given me by my friend Richard Brettell at the University of Texas, Dallas, in Winter 2006. At Northwestern University, Hannah Feldman was unstinting in her criticism; this book is much better for it. Georges Didi-Huberman of the Écoles des Hauts Études in Paris, and Visiting Professor of Art History at Northwestern during Spring 2006, shared with me some of his many insights into the work of Aby Warburg. Andrew Hemingway, Carol Duncan, Tom Gretton, David Craven and Alan Wallach all added their ideas and criticisms during meals and over coffee in England, at the university of Leeds in Spring 2006. The photos from Abu Ghraib prison were made available by salon.com, which provided an important public service in their publication. Northwestern University Slide Librarian, Roman

Stansberry, was an enormous help in obtaining and processing the photographic images. Finally, thanks are due to Mary Weismantel, my interlocutor of first and last resort. Without her intelligence, love and support, this book would not have been written.

Photographic Acknowledgements

The author and publishers wish to express their thanks to the below sources of illustrative material and/or permission to reproduce it. (Locations of artworks are also given below.)

Ashmolean Museum, Oxford: 47; The Art Institute of Chicago: 58, 66; British Museum, London: 24, 33, 45; photo Deering Library, Northwestern University, Evanston, Illinois: 8; Kunsthistorisches Museum, Vienna: 27; Metropolitan Museum of Art, New York: 46; Musée Calvet, Avignon: 53; Musée du Louvre, Paris: 34, 54; Musée Royale des Beaux-Arts, Brussels: 51; Museo Capitolino, Rome: 26; Museo del Prado, Madrid: 1, 3, 39, 56; Museo del Vaticano, Rome: 23, 52; Museo Nacional Centro de Arte Reina Sofia, Madrid (photo John Bigelow Taylor/Art Resource, New York, © 2006 Estate of Pablo Picasso/Artists Rights Society [ARS] New York); Museu Nacional d'Art de Catalunya, Barcelona: 40; Museum of Fine Arts, Boston: 4 (photo © 2006 Museum of Fine Arts, Boston; bequest of W. G. Russell Allen, 1974.223), 5 (photo © 2006 Museum of Fine Arts, Boston, bequest of W. G. Russell Allen, 1974.244), 19 (photo © 2006 Museum of Fine Arts, Boston, gift of Ms Katherine E. Bullard, M25682); Palazzo Pitti, Florence: 36; Pergamon Museum, Berlin: 22, 25; photo courtesy Ronald Feldman Fine Arts, New York: 66; The Royal Collection, Windsor Castle: 35; St Peter's, Rome: 41; photos courtesy of Salon.com: 2, 7, 10, 12, 13 (original photo by Spc. Charles A. Graner, Jr), 14, 15 (original photo by Spc. Charles A. Graner, Jr), 16 (original photo by Spc. Charles A. Graner, Jr), 17 (original photo by Spc. Charles A. Graner, Jr), 20, 28, 29, 63, 64; Solomon R. Guggenheim Museum, New York: 11

(gift, Robert Mapplethorpe Foundation, photo Solomon R. Guggenheim Museum); Tate Britain, London: 49.